Poppies

Blood Swept Lands
and Seas of Red

Poppies
Blood Swept Lands and Seas of Red

Artist **Paul Cummins**
Designer **Tom Piper**
Foreword by **HRH The Duke of Cambridge**

Published by IWM, Lambeth Road, London SE1 6HZ
iwm.org.uk

The installation `Blood Swept Lands and Seas of Red' by artist
Paul Cummins and designer Tom Piper was a collaboration
between Historic Royal Palaces and Paul Cummins and staged
at HM Tower of London in 2014 to mark the beginning of the
Centenary of the First World War.

ISBN 978-1-904897-51-4

A catalogue record for this book is available from the British Library

Designed by Ocky Murray
Printed and bound by Graphius in Belgium
Colour reproduction by Zebra

All images © IWM unless otherwise stated

10 9 8 7 6 5 4 3 2 1

Contents

On 5th August 2014, I was privileged to visit the Tower of London to commemorate the centenary of the first full day of Britain's engagement in the First World War. Even then, before the majority of the 888,246 ceramic poppies – each one representing a British or colonial life lost during the conflict – had been placed, the installation *Blood Swept Lands and Seas of Red* was a spectacular sight. Huge crowds had already gathered to experience the extraordinary work of artist Paul Cummins, designer Tom Piper and the team and volunteers of the Tower of London.

As the Patron of the Imperial War Museum Foundation, I have witnessed first-hand some truly innovative approaches to remembrance and how they connect the widest range of people with the First World War and its heritage. This book captures the story of the poppies throughout the centenary of the First World War, from their first appearance at the Tower of London and the tour of the two sculptures across the country; to their arrival at their long-term home at the IWM.

Between 1914 and 1918, the people of Britain and the Commonwealth demonstrated extremes of resolve and courage in the defence of our freedom and our values. There can be no greater lesson than this for our modern generation. It is my hope in exploring anew the idea of remembrance, that we continue the global conversation about the legacy of the First World War, long after the centenary is over. And that the example set by those - 100 years ago - can help to inspire hope and a commitment to strive for a better future for generations to come.

Paul Cummins

A note from the artist

Welcome to this visual retelling of the installation *Blood Swept Lands and Seas of Red*, which was housed at the Tower of London from August to November 2014. The installation, made up of 888,246 handmade ceramic poppies on metal stems was, at the time, my largest artistic undertaking, and due to those who came from across the globe to engage with the piece, became something that took on a life, and now a legacy, of its own.

As an artist, I'm always looking for new inspiration. While I'd had the idea for a large-scale installation to commemorate the First World War in my head for a long time, it wasn't until one cold day in September 2012 – when I'd taken shelter from the rain in a Chesterfield library – that inspiration struck. I was looking through artifacts and discovered the will of a soldier who had been one of the tens of thousands killed in the First World War. A soldier who was actually female, posing as a man so she might fight.

Her words describing the war raging around her, 'Blood swept lands and seas of red, where angels dare to tread...' created a vision of red in my mind. This vision spawned an idea: a flower to represent every British and colonial soldier killed in the First World War. With the centenary of the start of the First World War fast approaching, it seemed appropriate to get this installation in place to coincide with the remembrance.

I feel that art affects us in different ways, and we're so used to seeing violence and bad news that it often takes a visual showcase of the sheer number of casualties an event can cause to affect a person and show them the futility of war. The exact number of lives lost that needed to be represented for this project was 888,246 – an enormous loss of life, which I hoped, once visually showcased, might bring new meaning to viewers.

For me, nature embodies creative life force and flowers tend to be my inspiration. Flowers, while beautiful, have a journey that will end. They have transience, just like every living being. I already knew what I'd like the flower to be for this installation, a symbol of remembrance known across the globe – the poppy.

For the 'Blood Swept Lands' poppies I chose to take inspiration from a Canadian poppy species. This was for two integral reasons: firstly, I wanted the poppy to represent not just the losses in Britain, but also the colonial losses from the First World War, too; secondly, this poppy is sometimes found with six petals, mirroring the six service charities chosen to receive the proceeds of those sold to the public.

Once I'd mocked up imagery and examples of the ceramic poppies in the precise colour I created, based upon cadmium red, I needed to find a home for the installation. I had a few venues in mind; however the amount of flowers, and the fact that they were ceramic, meant that there were considerations. The art needed a very large area that was sheltered from public access but allowed large-scale public viewing. It was then when I thought of the Tower of London. This historic location had a moat large enough to hold the number of poppies required with restricted access, 360 degree viewing and a strong connection to the First World War.

I approached the Tower of London by phone and, due to a happy accident, I was inadvertently put through to their head of operations. Following this, having gained their interest, I met Historic Royal Palaces with my idea and created CAD drawings

of the overall concept, with thousands of flowers ebbing and flowing around the moat. The creation of the two key sculptures, *Wave* and *Weeping Window*, came later during the planning stages of the installation, while working with designer Tom Piper and Historic Royal Palaces on the actual planting and staging of the poppies.

Then came the huge task of creating over 800,000 handmade ceramic poppies to fill the Tower of London's moat. In all my previous projects I created each flower myself, however the sheer number of flowers that needed to be created, coupled with an injury I sustained whilst rolling clay to make a poppy, meant I had to bring in a team of artists to help me create the flowers.

I prefer traditional methods of creation, so I use as little machinery as possible. To create these poppies I used earthenware clay that was sliced, then rolled so it could be shaped. Using two poppy stamps, one small and one large, two clay cut-outs were made then placed one atop the other and a hole was cut for the stem. Then, each flat clay design was hand-moulded into a poppy. As each poppy was handmade, each poppy is as individual as the soldier it represents.

As timescales got shorter, teams from Derby and Stoke-on-Trent were contracted to help create around 20,000 poppies a day that were then transported to the Tower of London and put in place by volunteers from around the world. Each day, more and more poppies were added to the moat and the sea of red grew.

The idea of selling the poppies as individual pieces and donating proceeds to charity came from another project I'd created back in 2010. With 'Blood Swept Lands', because these flowers each represented a life, it really made sense that their creation as a piece of artwork would be not only placed on display as a whole installation, but each poppy be treasured, be taken home, and their purchase would give back to charities that support the armed services.

The fact that over £9 million was raised for these six service charities is truly staggering. The poppies sold out even before the installation came to an end, and I am still taken aback at people's support and love for them.

As with all my work, including 'Blood Swept Lands', engagement is integral. It has been part of my artistic process for the last decade. With all the art I create, I strive to encourage participation as I feel that when people experience art for themselves it completes an installation.

Volunteers came to help 'plant' poppies and share stories about remembrance. Soon, the Tower of London had millions of people from all reaches of the globe flocking to its gates to see the poppies – while incredible, it was completely unexpected. It was quite amazing to see people's reactions to the work, and how it brought people together.

11 November 2014 is a day I will never forget. Whilst standing in a field of red, surrounded by ceramic flowers we placed the final poppy. Thousands of people looked on as we stood for a moment's silence amongst the flowers representing the war dead. It was a nerve-wracking and emotional moment for me, seeing the installation complete, with so many people looking at the work around me. I was taken aback, wholly, by the response, and I feel so privileged to have created a piece of art that has touched so many people. While, for me, the response was unexpected, it was actually the reaction I wanted to create for the public, albeit much larger than I'd ever imagined.

What I had always wanted was to bring people together, to create a feeling of connectivity, solidarity and remembrance across the globe. It became a true collaboration, and I'd like to extend my many thanks to all the volunteers who dedicated their time to plant the poppies, to my team members for the flowers – and the memories, to Historic Royal Palaces and the Tower of London for taking on my vision and allowing us to use the moat as our staging area, to Tom Piper for his incredible eye and skills, to all those who had a hand in helping to turn my idea, which seemed implausible, into a reality. And thank you to 14-18 NOW and all who made the tour possible, for continuing to tell the stories of the poppies.

Lastly, thank *you*, the public, so much for your support, your memories, your donations to the charities and for embracing the poppies with such fondness; thanks to you, the war dead will always be remembered.

Dr. Paul Cummins MBE

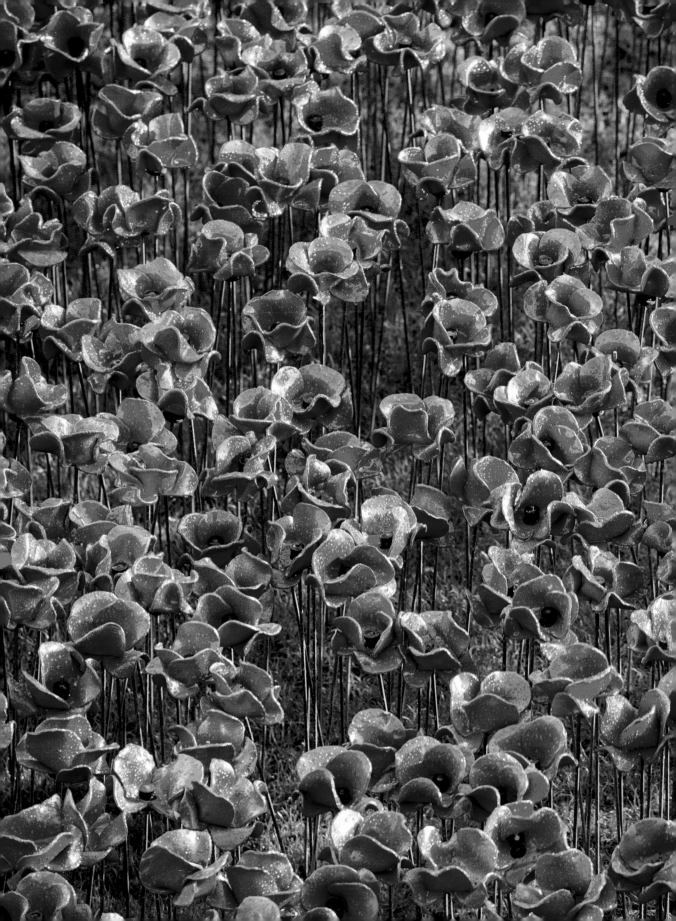

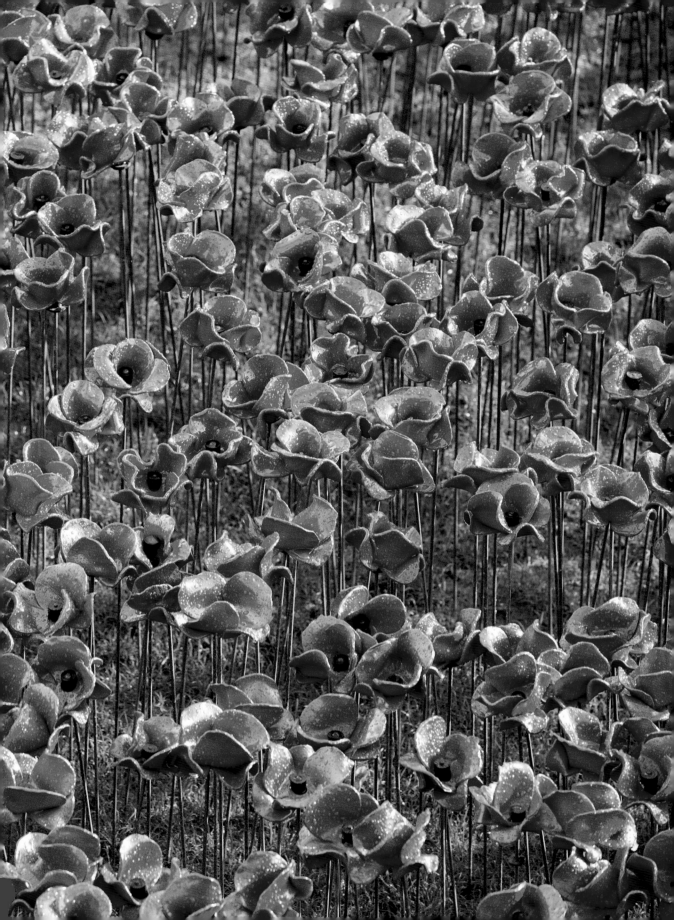

Tom Piper
A note from the designer

Well. I had no idea how epic it would be and quite beyond the scale of anything I imagined or have done before. It became a project of so many strands and layers and meanings. What began as Paul Cummins's bold and brilliant idea of making 888,246 poppies to reflect the British and colonial fallen in the First World War became so much bigger than the sum of the individual contributions. Once approved by the Tower of London, the organisation of the major artwork was taken on by Deborah Shaw at Historic Royal Palaces, who then involved me to work on the design of the dramatic installation. From there it became a project that so many contributed to in so many ways; by planting or removing or by buying a poppy – and so ensuring their subsequent distribution around the world – or by suggesting names for the Roll of Honour of the fallen each evening for the 'Last Post', and perhaps, most importantly, anybody could come, free to look, watch and reflect.

I had always hoped we would create something that was very different to the Flanders Field memorials, which are chillingly beautiful in their ordered formality. For me this had to be about the fragility of life, the spirit and energy of all those young lives, something that would celebrate them and at the same time mourn their loss. Paul's title of the piece led very simply to the metaphor of the mass of poppies behaving like blood, seeping from the tower, or crashing over the ramparts in waves, like the waves of young men going over the top in the trenches. The tide of red gradually filling the moat until, by 11 November 2014, no green grass was left uncovered. When the last poppy was planted there was a single day of stillness before

we immediately started taking the poppies out again, so the installation was never a fixed, finished piece. The fact that the project was in a continual state of flux and we didn't really know quite what it was going to be or what would happen next was the making of it.

There was originally the possibility that the installation would go unnoticed, as the moat is only visible when the visitor is right above it, looking down from the edge. It was clear to me that the display needed height, so we created three sculptural installations at key viewpoints that rose up out of the moat and were visible on the route from the tube station, as you crossed Tower Bridge and from across the river.

We had initially planned a grand unveiling of the finished installation on the anniversary of the outbreak of the war on 5 August, but it soon became clear that there was no way we would be able to hide the growing fields of red from the public, nor indeed could we plant so many in such a short time. So the decision to allow the planting to happen gradually was made in June, barely a month before our planned start date; the new aim was that the installation would be finished in time for Remembrance Sunday 2014. We recruited 25,000 volunteers, marshalled by Kirsty, Julian, Jim and their teams at the Tower of London, planting about 80,000 poppies a week. They brought an individuality to the planting which gave the overall piece the natural, flowing feel that was so evocative and added so much. The central theme of a single poppy for a single life enabled the public to invest at a personal level, as so many families have been prompted to look back in their histories to find out about past war experiences. Many of

the volunteers had a much closer connection to more recent conflicts, either serving in the current armed forces or having relatives who served. Each gave up four hours of their time to hammer stakes into the ground, add washers and the ceramic poppy heads. We couldn't really control how they planted; there was a scheme, but each team did it slightly differently and the different densities and patterns gave the work an organic feel. It was a truly collaborative artwork.

On another level, the project has had a far bigger societal impact, as the scale of the installation and the length of time it took to make and plant all the poppies seemed to bring home the sheer scale of the war and the losses it involved. There were times while I was installing that we kept calling for more poppies to fill gaps, forgetting momentarily that each one represented a life, each new unpacked crate was another 20 lives, each symbolising an individual but disappearing as drops into the sea of red. The three sculptures – *Weeping Window*, *Wave* and *Over the Top* – each contained just 5,000 poppies, a tiny fraction of the 888,246, but provided a key structure for the piece and allowed the metaphor of the poppies as blood to be easily read in a simple yet striking way.

On 8 September I walked out, accompanied only by a military bugler, into the mass of poppies. I approached the small raised mound we had created under the west wall and stood, before what seemed like a vast crowd watching from above, to read out 150 names chosen by the public to commemorate their lost relatives. It was a nerve-wracking and sobering experience trying to give the reading of each name the dignity they deserved. My group came from all over the world, with losses from India, New Zealand and Canada, as well as all those from so many parts of the United Kingdom. Across all races, ranks and classes they were united in death and given a moment of commemoration and thanks for their sacrifice.

The work is a celebration of the lost life force and energy of those lives cut short, far from sentimental. The flowing nature of the piece, with the poppies pouring from the tower and swirling around the moat and over the bridge, gave it an energy and a monumental power which I hope was a positive commemoration of those lives, while at the same time challenging us to ask the question, 'why?' To me, a pacifist, it seemed to ask the wider universal question of what is the real human cost of any war.

As the installation neared its end and nearly all the poppies had been sold we began to discuss how we might save the sculptural installations as individual artworks in their own right, and we were so fortunate that two charitable trusts stepped in to buy those final poppies and gift them to the nation for a tour and subsequent residency at IWM. So, the installation has lived on in a fragmented yet powerful way with the 14-18 NOW Poppies Tour and the online map 'Where Are The Poppies Now', which has created a virtual global installation and contains thousands of testimonies about what the poppies mean to individuals, and a moving record of their family history. It has been extraordinary to witness the continuing power of the poppies to inspire and engage people wherever they have been seen, from Orkney to Plymouth, Southend to Belfast.

It was humbling and overwhelming to see all the comments on social media, the vast crowds who came to look and reflect, and the work of thousands of volunteers and Paul's team making the ceramic flowers. So much work but such an impact on the nation.

I cannot end without expressing grateful thanks to Lily Arnold and Emma Bailey who assisted me, Deborah Shaw and John Brown and all at the Tower who stood by the project through all its immense challenges, all the team leaders of the volunteers under Julian Cree, Seb and Martin at TR2 in Plymouth who made all the structures, the scaffolding company, all the Yeoman Warders, all the charities, volunteers and the public who have taken this amazing project to their hearts, to the amazing team of poppy manufacturers and above all to Paul for his original inspirational idea.

Tom Piper MBE

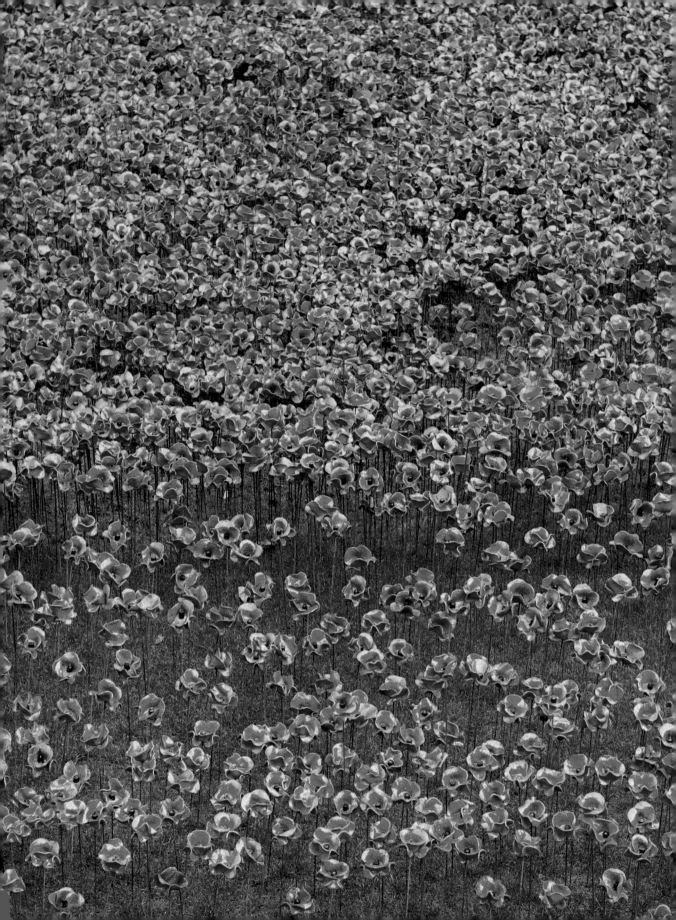

Blood Swept Lands and Seas of Red

By Anon (Unknown Soldier)

Blood swept lands and seas of red,
Where angels dare to tread.
As I put my hand to reach,
As God cried a tear of pain as the angels fell,
Again and again.
As the tears of mine fell to the ground,
To sleep with the flowers of red,
As any be dead.
My children see and work through fields
of my own with corn and wheat,
Blessed by love so far from pain of my resting
Fields so far from my love.
It be time to put my hand up and end this pain
Of living hell, to see the people around me
Fall someone angel as the mist falls around,
And the rain so thick with black
thunder I hear
Over the clouds, to sleep forever and kiss
The flower of my people gone before time
To sleep and cry no more.
I put my hand up and see the land of red,
This is my time to go over,
I may not come back.
So sleep, kiss the boys for me.

The Tower of London

July–November 2014

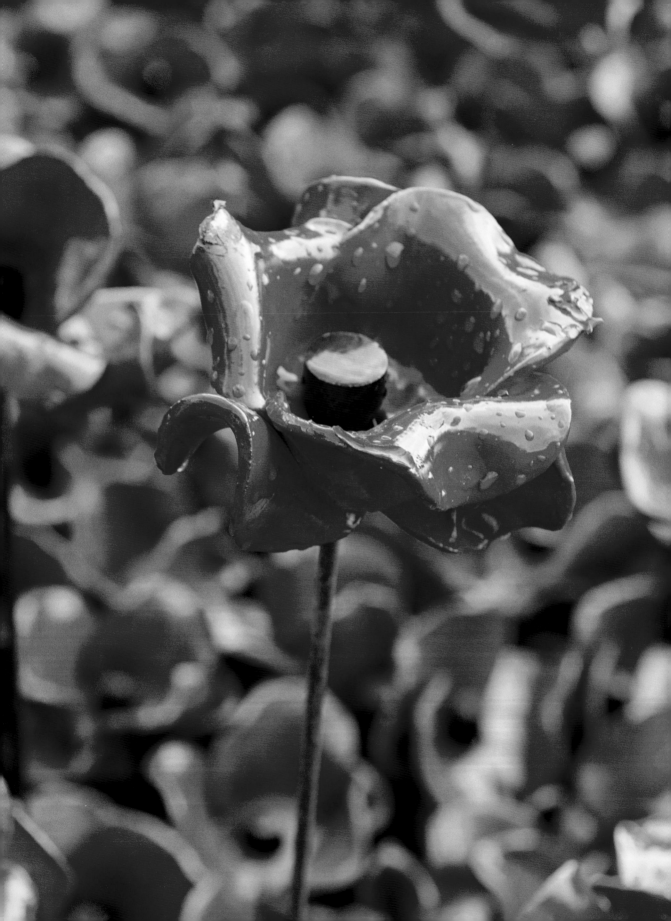

Three hundred people across three different sites rolled, cut and shaped by hand each individual ceramic poppy over the course of almost a year. Each poppy is unique, made up of six petals and represents a British or colonial life lost during the First World War.

On Thursday July 17 2014, the
very first of 888,246 ceramic
poppies was planted by
Crawford Butler, the longest
serving Yeoman Warder at
the Tower of London.

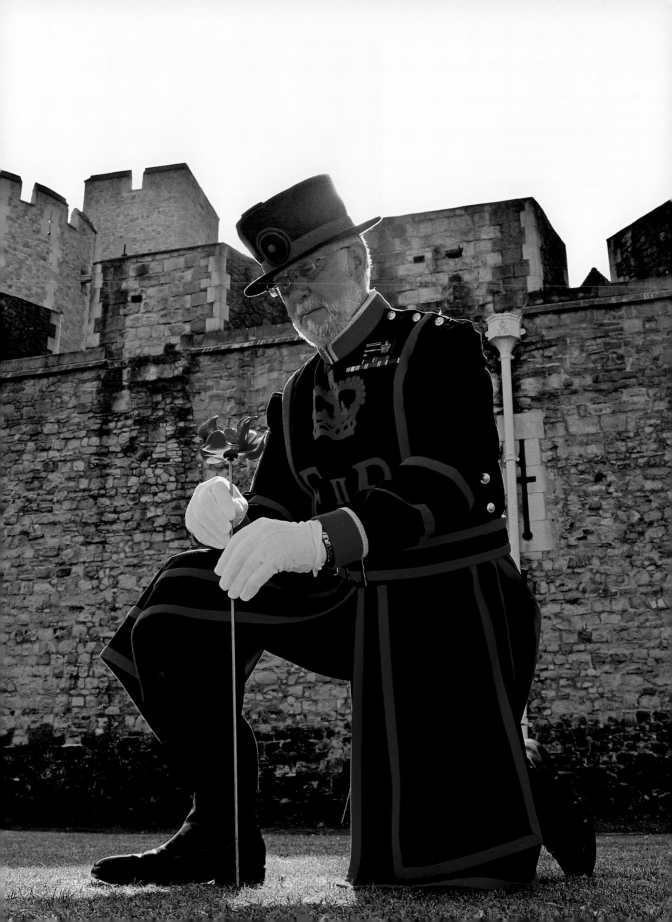

It would take an army of over 20,000 volunteers nearly 4 months to completely fill the moat surrounding the Tower of London. Many volunteers had service backgrounds, others identified a single poppy with a personal loss while many were just happy to offer their time.

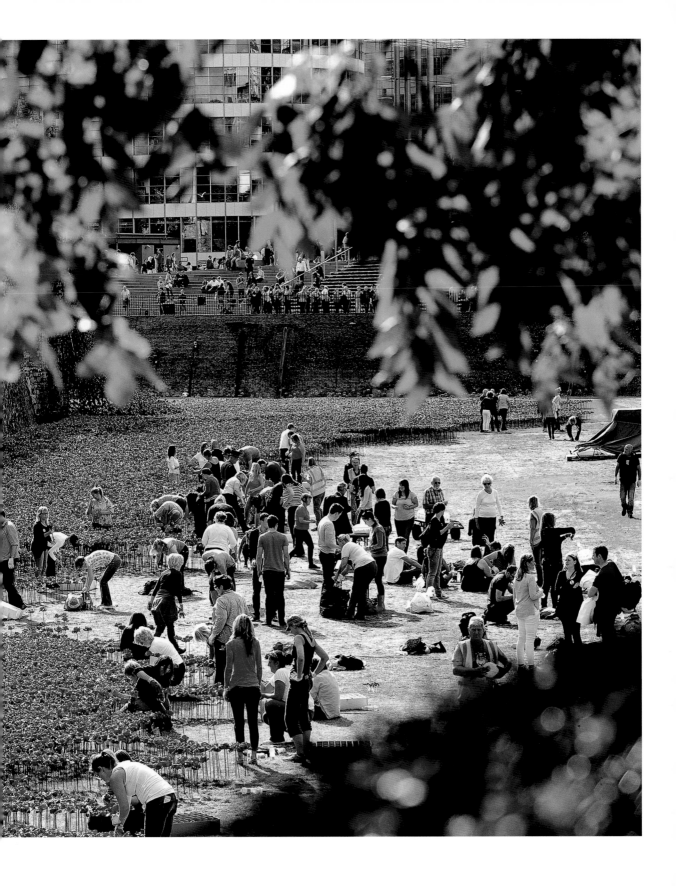

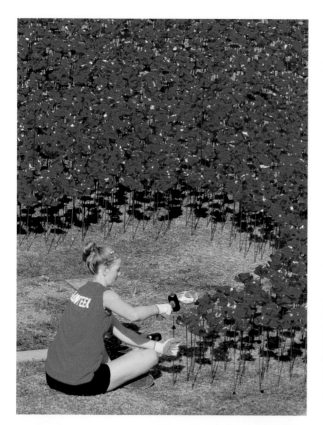

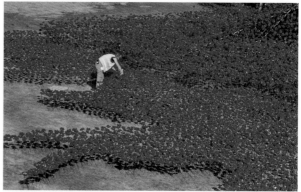

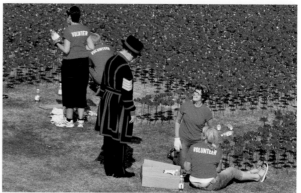

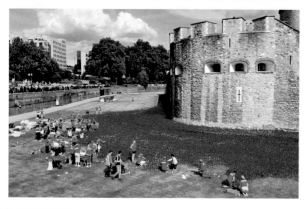

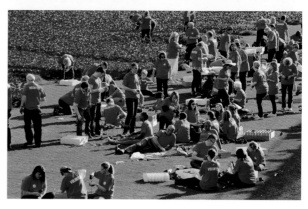

'I wanted to pay my
respects to all of the
servicemen who gave
their lives hundreds of
years ago so that we
could have the life we
have today.'

Poppies Volunteer

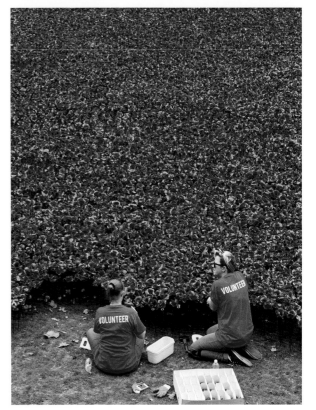

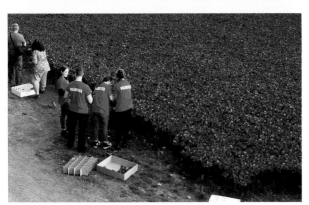

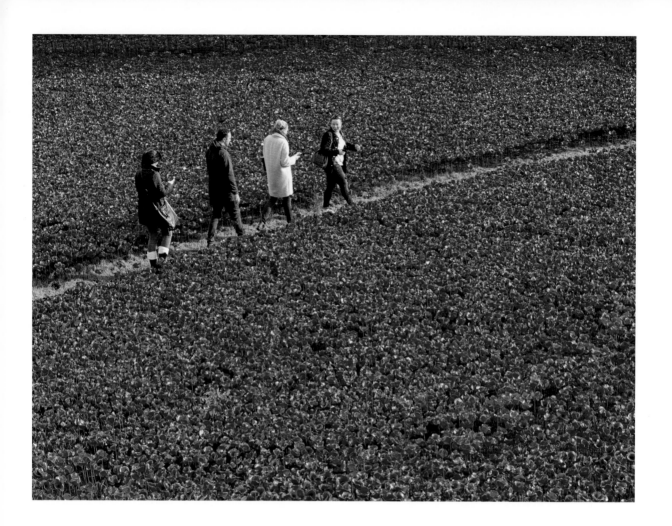

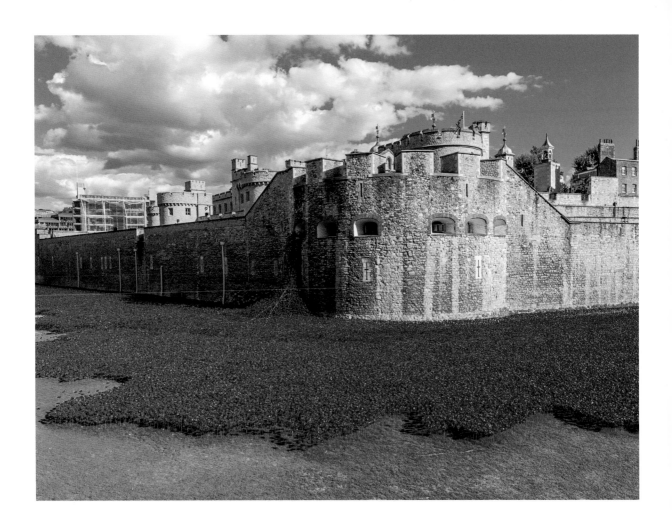

The moat soon began to fill with poppies, spreading further and further away from the edge of the Tower of London. Contour guidance lines were sprayed on the ground so that volunteers knew where to plant their poppies. Pathways were created through the vast sea of red to allow volunteers, organisers, Beefeaters and special guests to walk the moat safely.

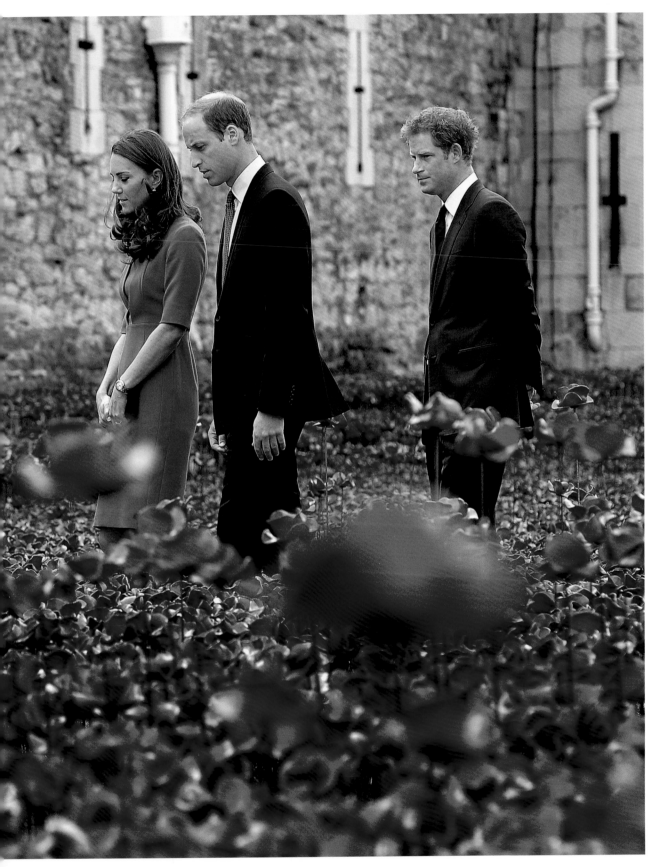

On 5 August 2014, the
installation was officially
opened by the Duke and
Duchess of Cambridge and
Prince Harry. This marked the
centenary of the first full day
of war with Germany, with the
official declaration having
come at 11pm on the 4th
August 1914. Met by General
the Lord Dannatt, then
Constable of the Tower, each
member of the royal family
planted a poppy.

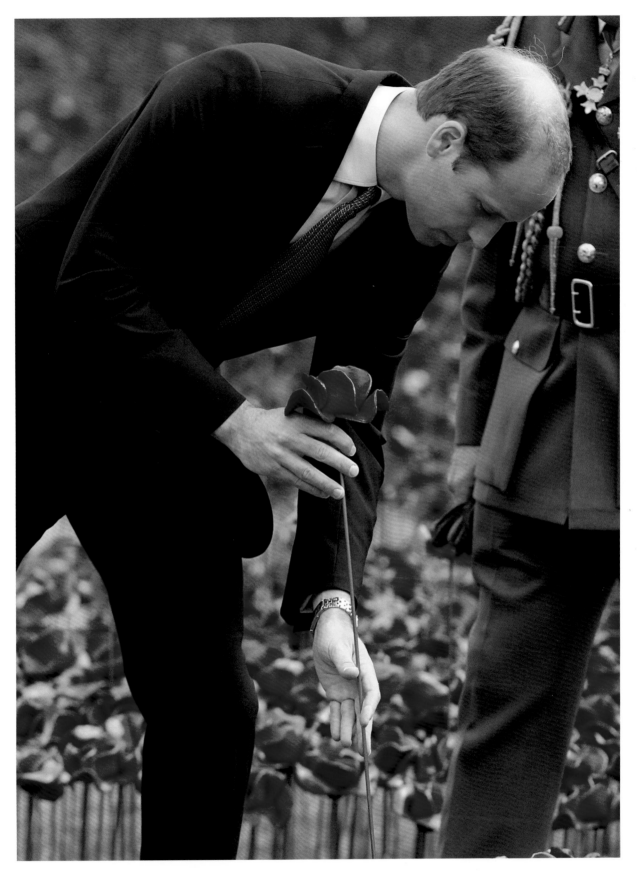

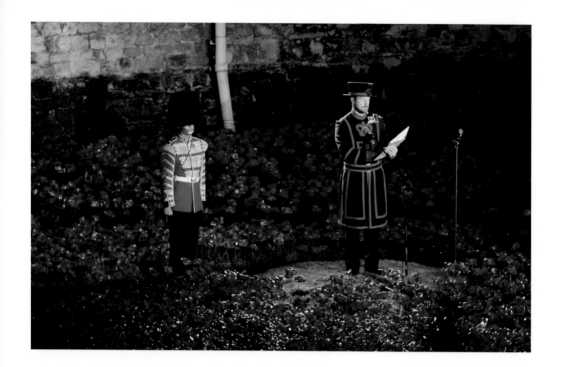

Each day, at sunset, the names of approximately 150 British and colonial troops killed during the war were read out as part of a Roll of Honour, followed by a rendition of the 'Last Post'. Members of the public nominated names for the Roll of Honour to be read the following week. This nightly ceremony regularly drew large crowds and the names were read by a number of well-known public figures, such as actress Dame Helen Mirren, Brian Cox and *War Horse* author Michael Morpurgo (pictured opposite).

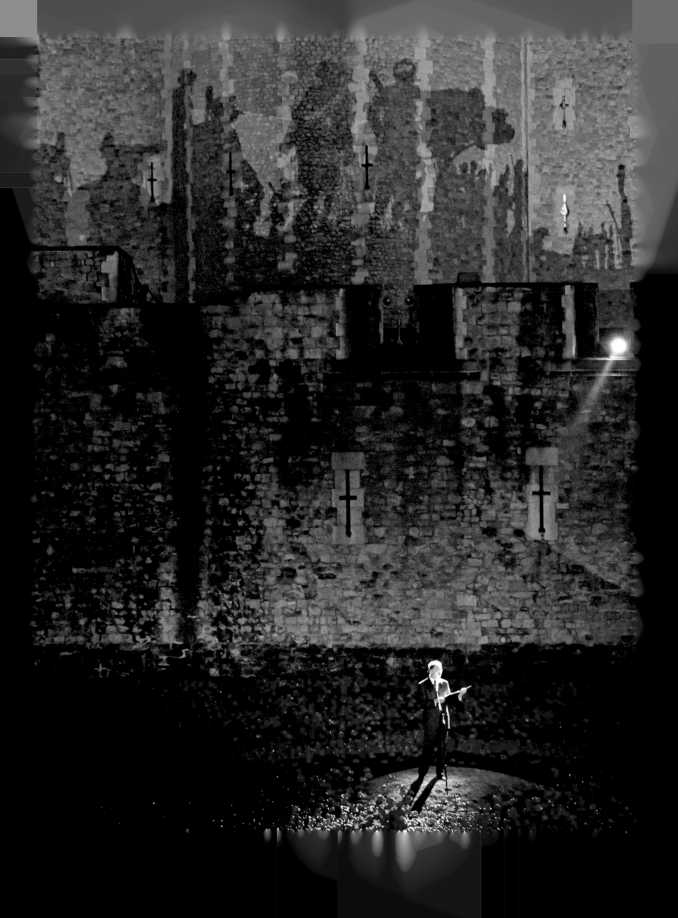

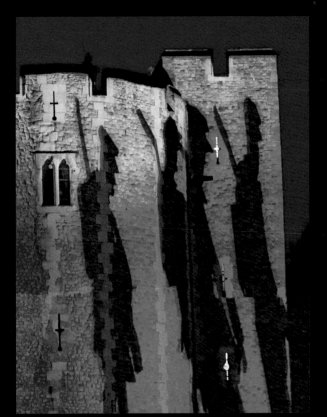

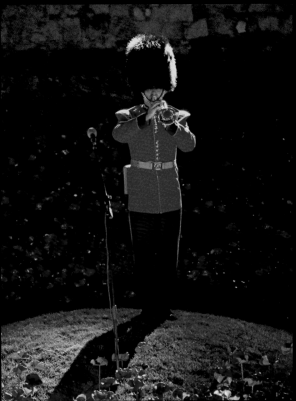

On the evening of 5 August, the official opening night, a specially commissioned projection accompanied the reading of the Roll of Honour, and the walls of the moat and the White Tower were lit up in the distinctive poppy red.

Complementing the sea of red were key, dramatic sculptural elements – *Wave* and *Weeping Window*. The former is a sweeping arch of bright red poppy heads suspended on towering stalks, which appeared to break over the heads of those crossing the bridge over the moat to access the main entrance of the Tower of London.

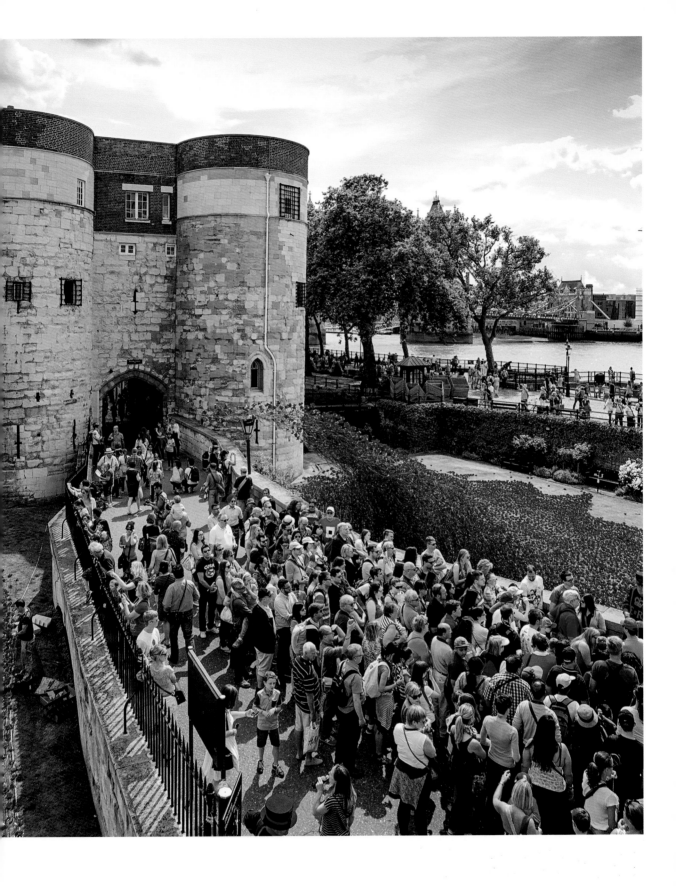

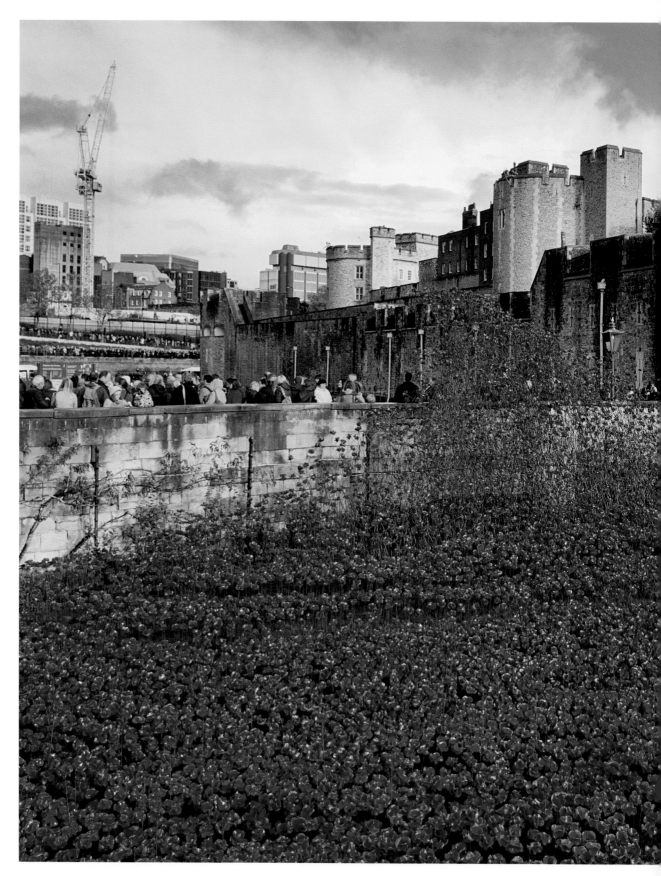

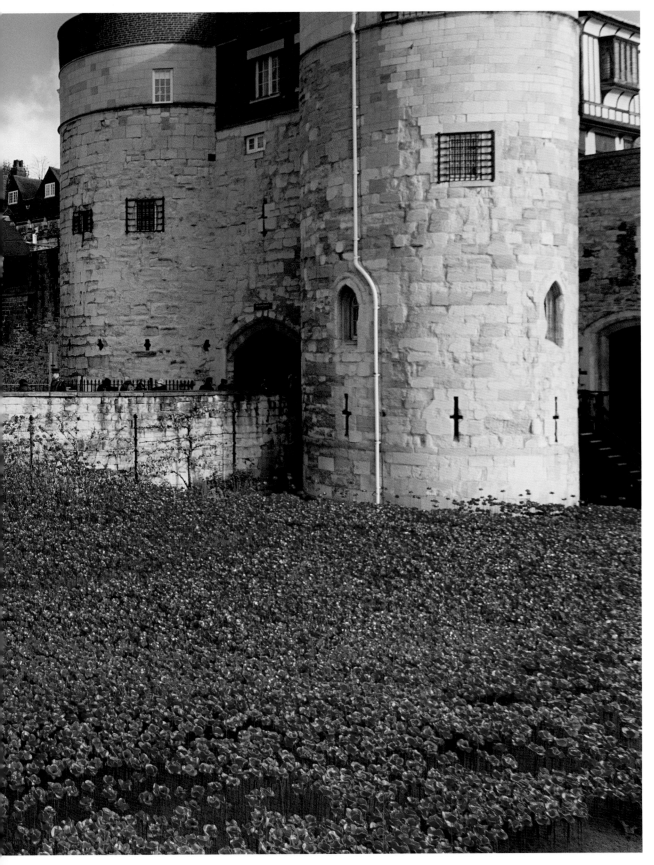

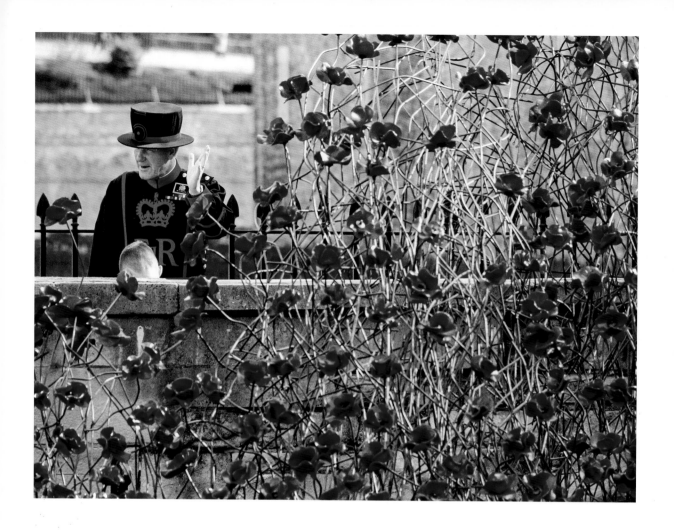

Supported by a major
donation from the Clore
Duffield Foundation, it was
bought and gifted to the
nation, allowing *Wave* to
tour the UK and be seen by
many more people.

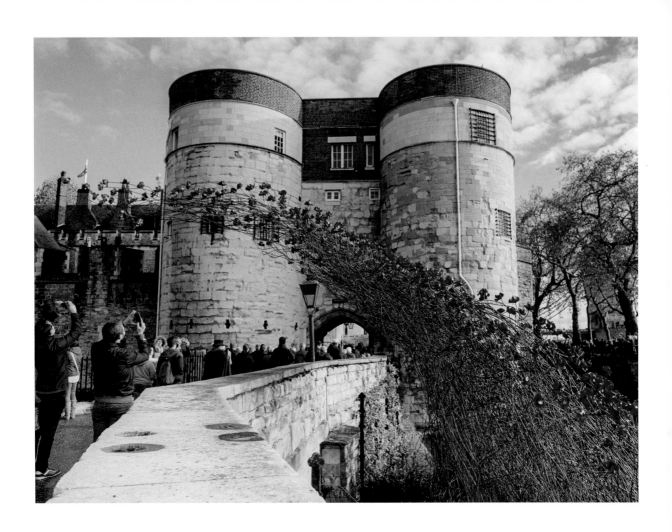

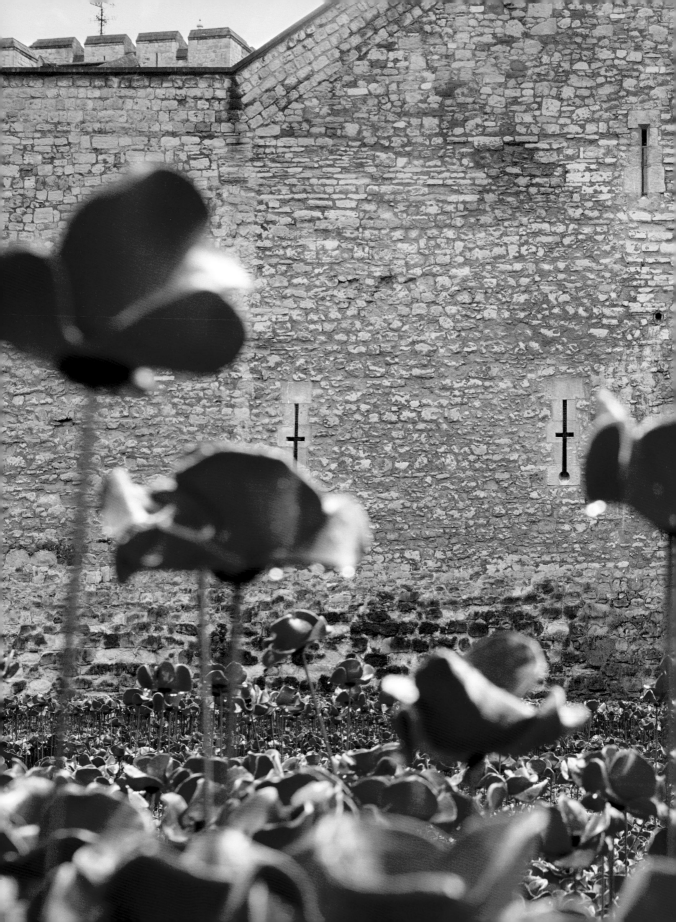

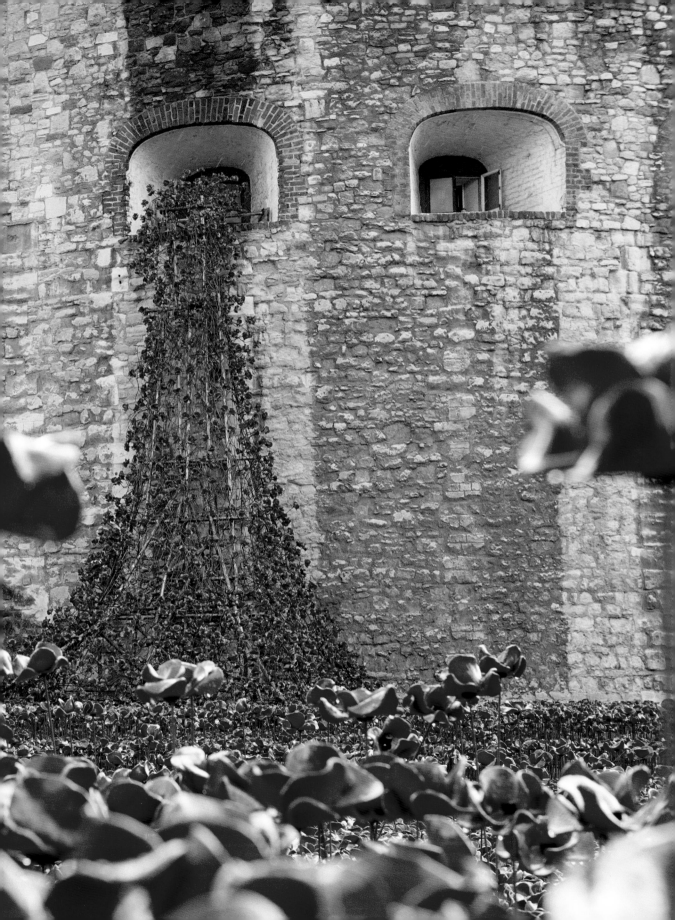

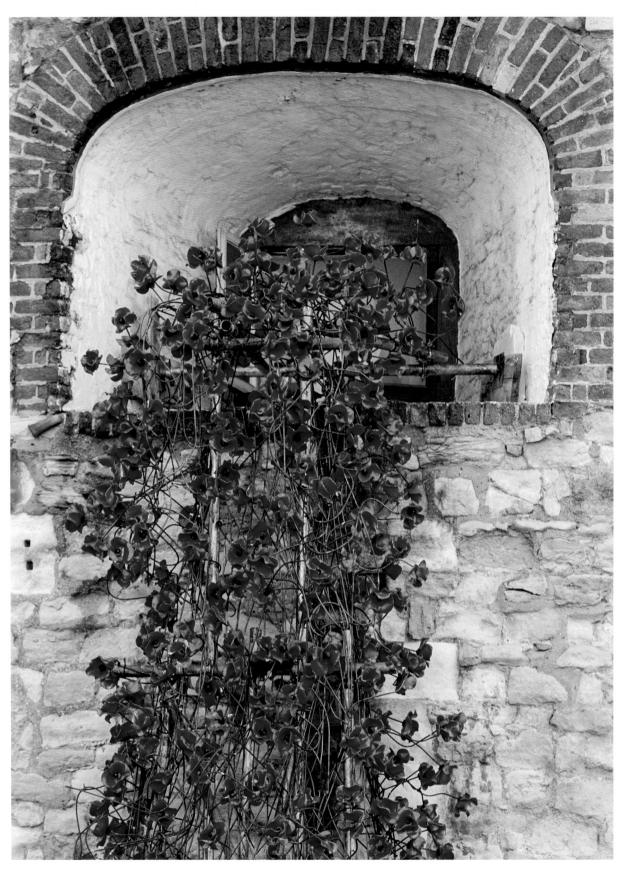

Weeping Window could be seen cascading down the side of the north-west bastion of the Tower known as Legge's Mount. This corner of the outer ward features the only medieval battlements remaining at the Tower of London, and provided an incredible setting for one of the most breathtaking elements of the *Blood Swept Lands and Seas of Red* installation. Thanks to a generous donation from the Backstage Trust, *Weeping Window* was also gifted to the nation and the 2 sculptures will have toured to 19 different venues across the UK by the end of 2018.

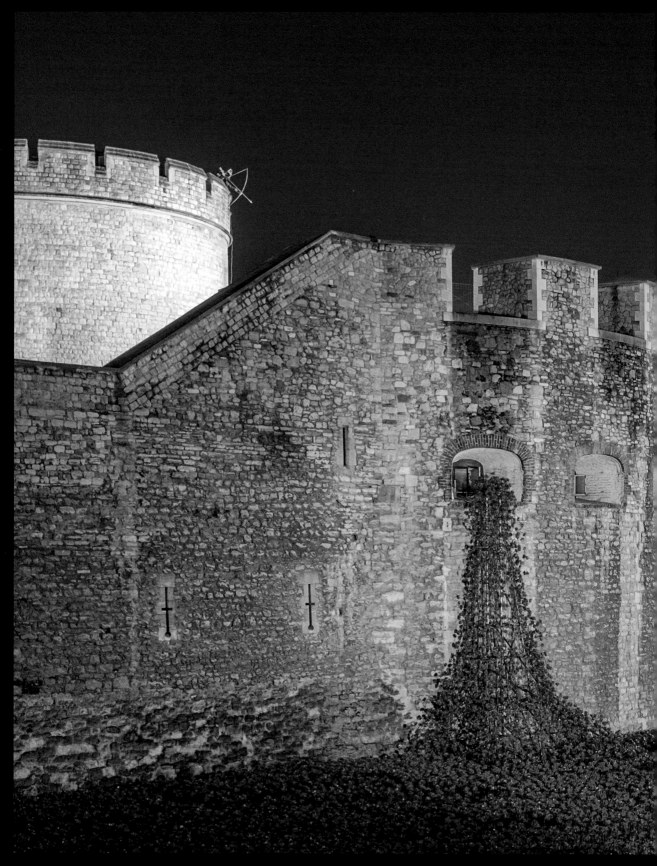

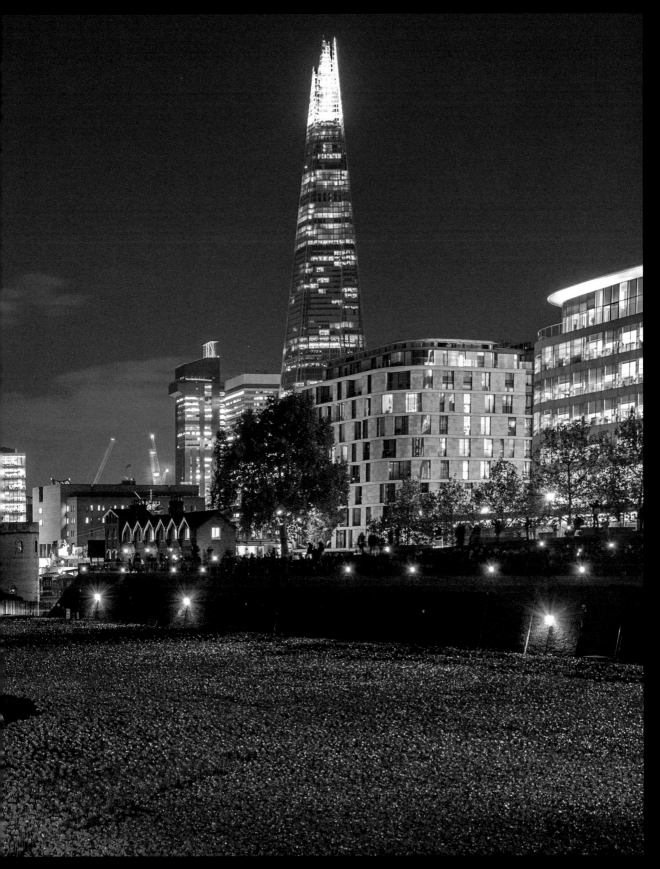

As the moat quickly filled with a sea of flowers over the course of several weeks, the crowds, too, began to swell. While the most immediate view of the installation was from the outer wall itself, perhaps the most spectacular was from the top of The Shard, the tallest building in the UK. The sheer number of people surrounding the Tower of London led to others taking more unusual measures to view the artwork, including taking a trip on the number 15, a double-decker bus that stops outside.

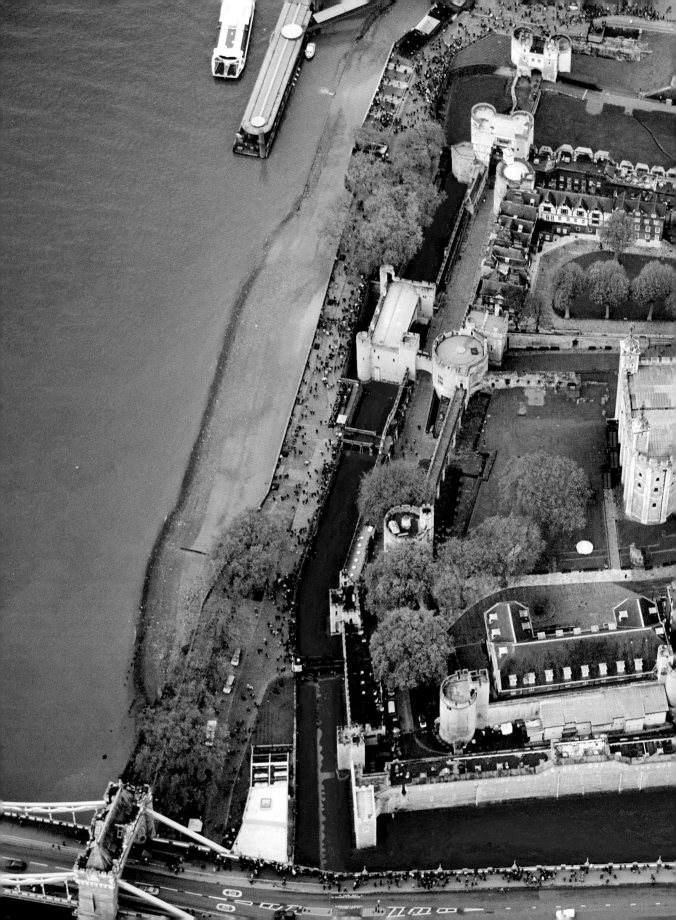

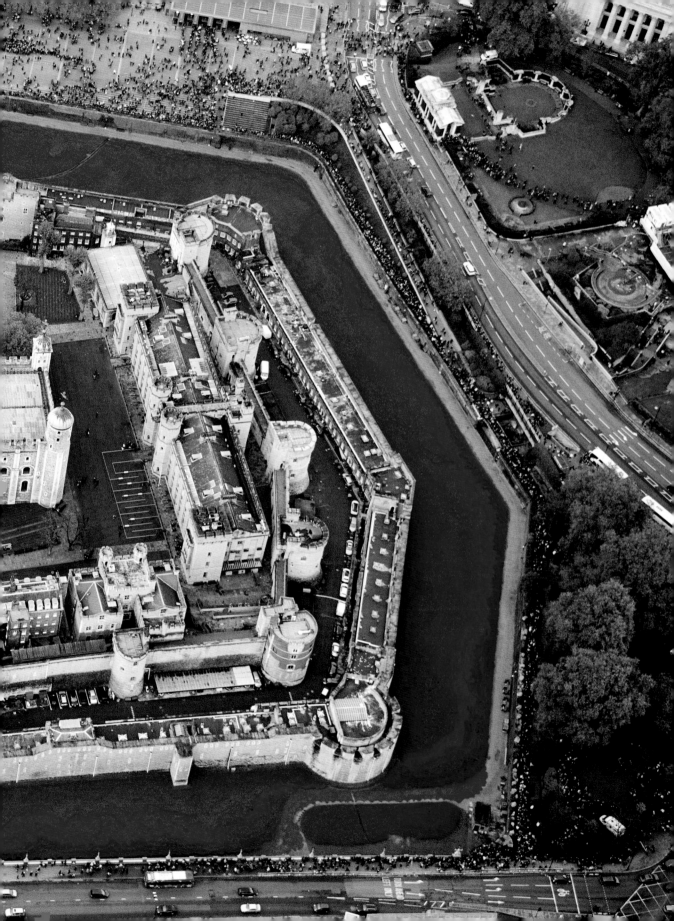

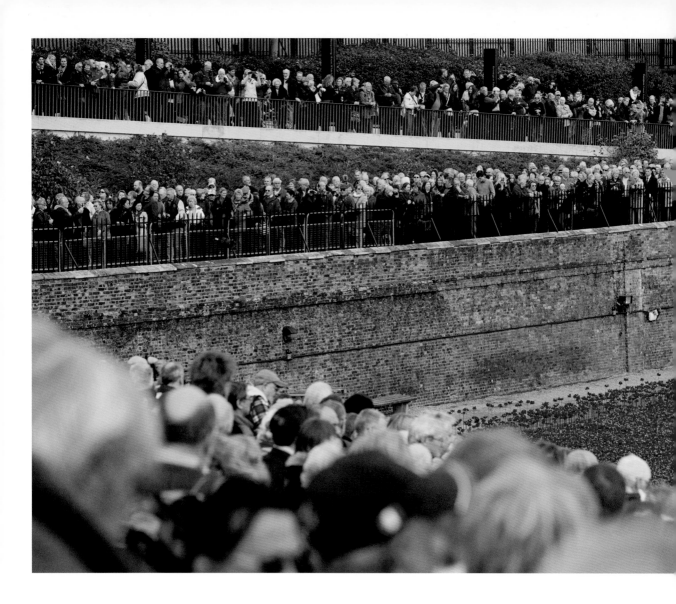

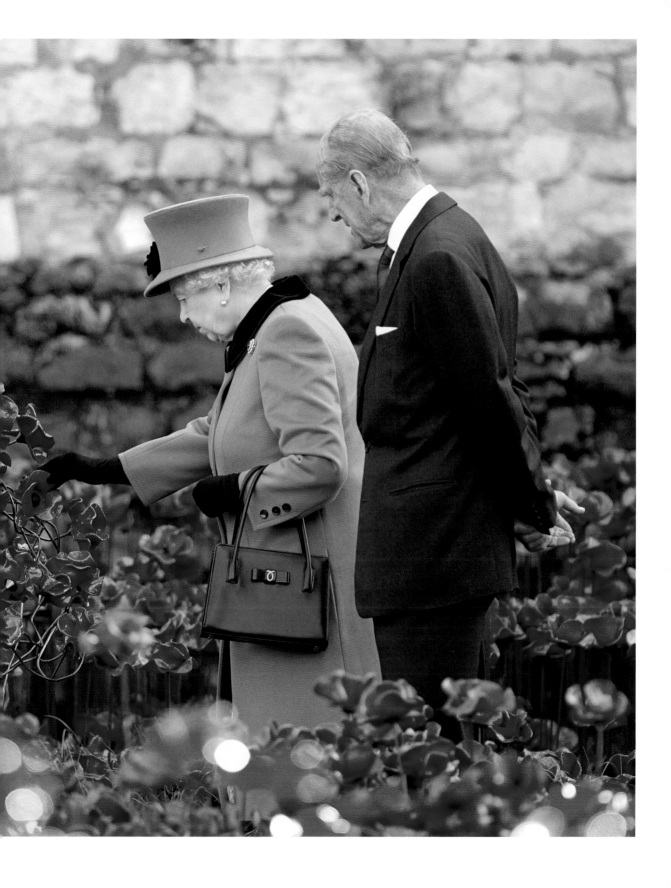

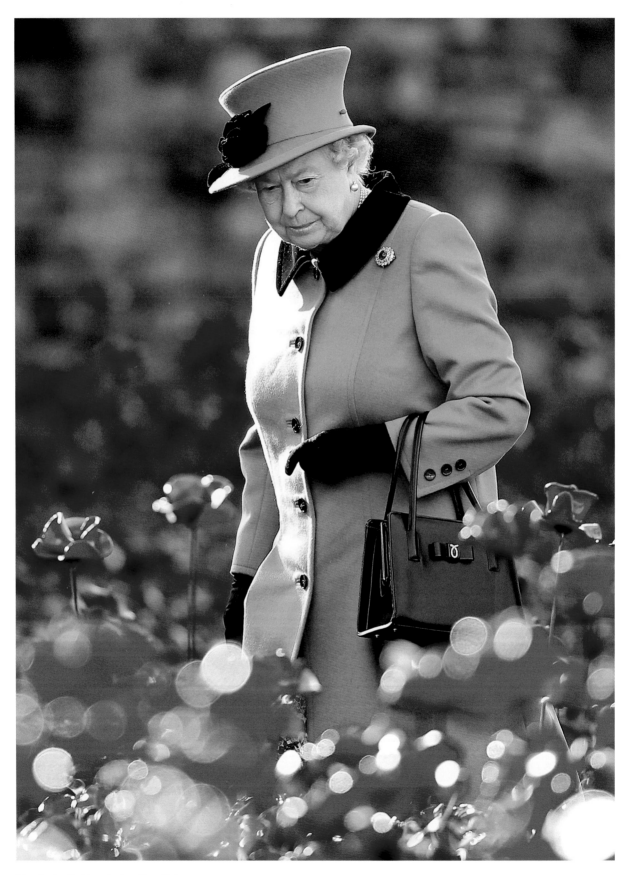

On 16 October, The Queen and The Duke of Edinburgh paid a visit to the installation. Having been greeted by the Constable and the Governor of the Tower, they made their way to the centre of the moat where The Queen was presented with a wreath of ceramic poppies. This was placed on a raised mound by Yeoman Warder Jim Duncan. Later, The Queen and The Duke of Edinburgh attended a private service at the recently restored Chapel Royal of St Peter Ad Vincula, the parish church of the Tower of London and the burial site of three famous queens — Anne Boleyn, Catherine Howard and Lady Jane Grey.

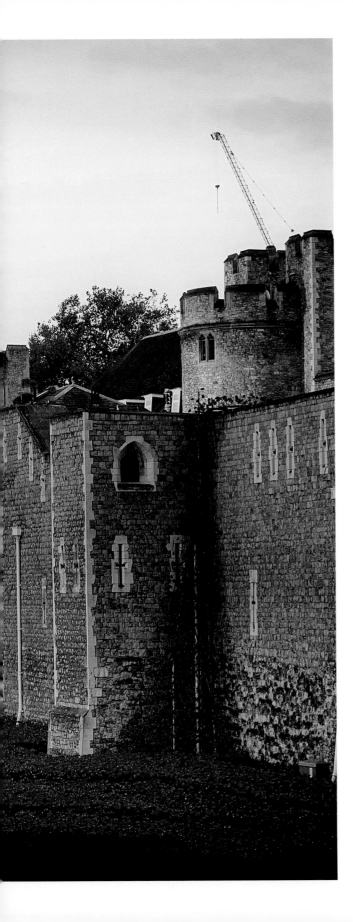

'I was left in awe at the sheer scale and strength of the piece. For me this is public art at its most powerful and moving'

Sajid Javid, then Culture Secretary

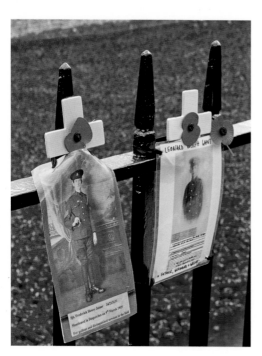

While the ceramic poppies planted within the Tower of London walls represented the British and colonial lives lost during the First World War, as the installation neared completion the outer railings became increasingly covered with more personal tokens of remembrance. Many of these memorials, including poppy crosses and knitted poppies, paid tribute to lives lost in past and more recent conflicts, showing how the poppy as a symbol of remembrance has transcended an individual war.

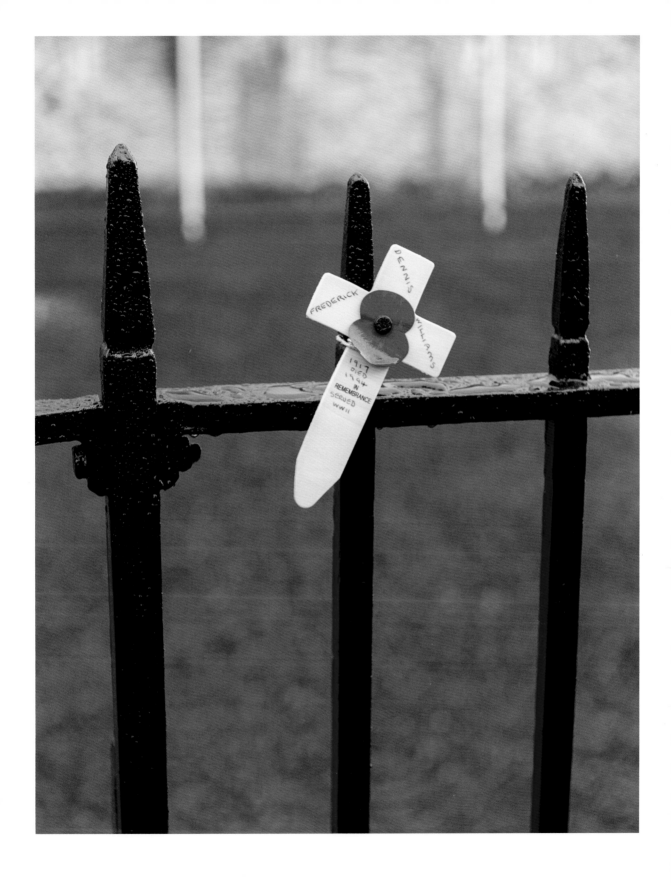

Blood Swept Lan

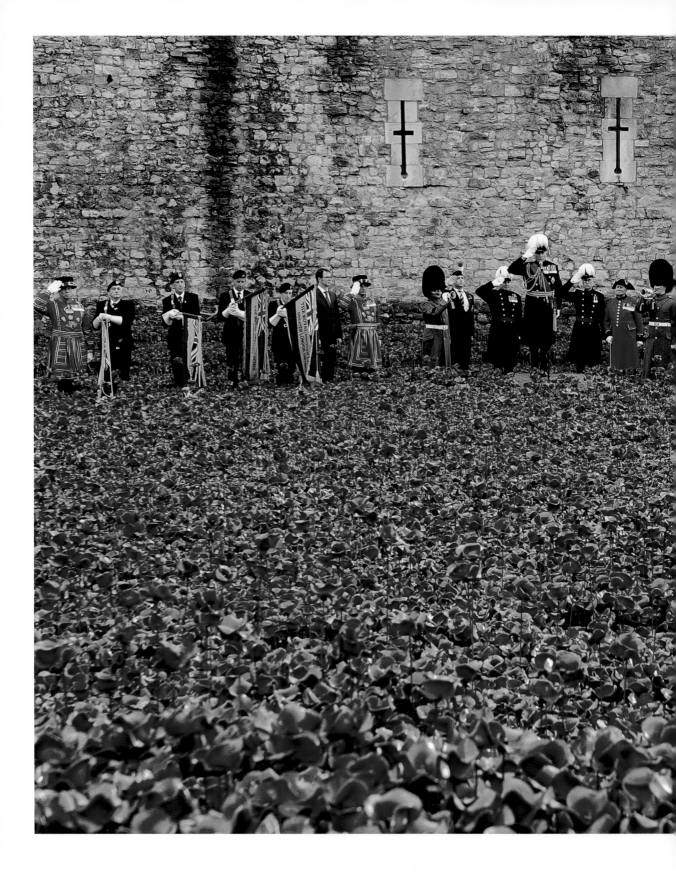

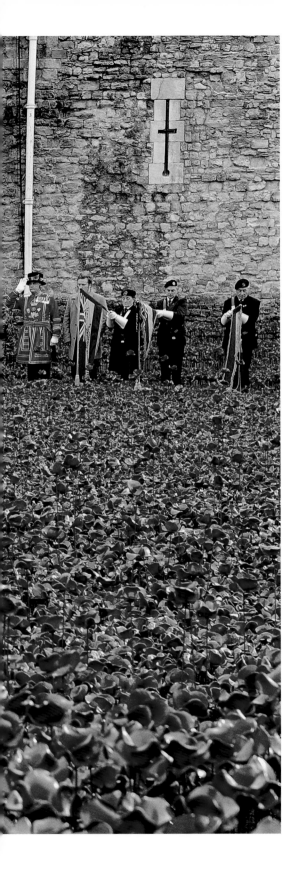

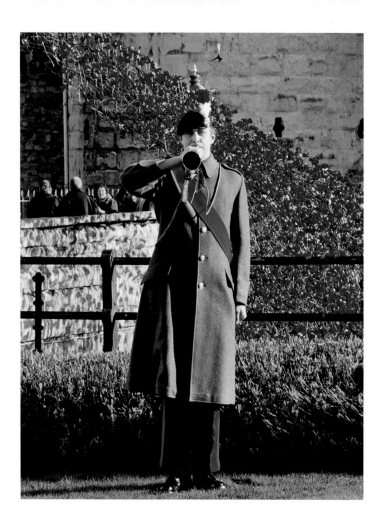

On the morning of 11 November 2014, huge crowds gathered to witness a 21-gun salute performed by the Honourable Artillery Company. The final names of the Roll of Honour were read aloud, before 13 year old Berkshire cadet Harry Hayes stepped forward to plant the final poppy. The 'Last Post' rang out shortly before 11am, when the thousands watching joined with those around the country for a two-minute silence to mark Armistice Day.

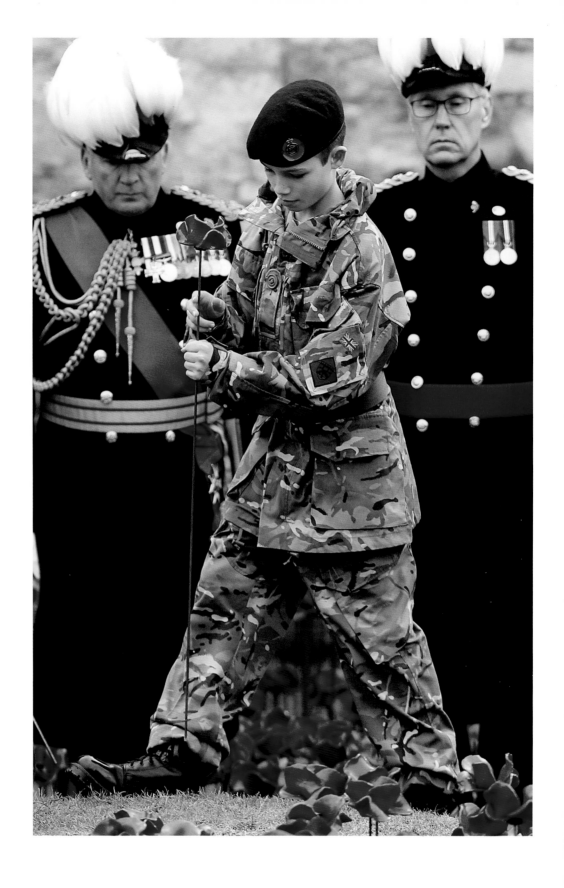

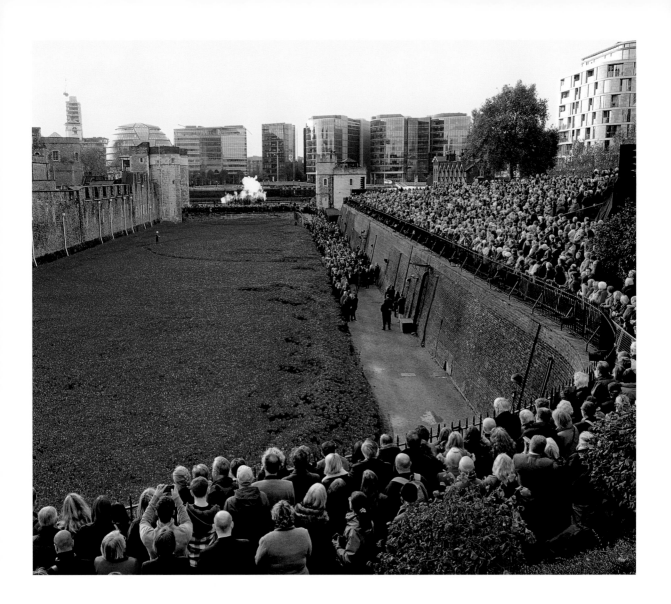

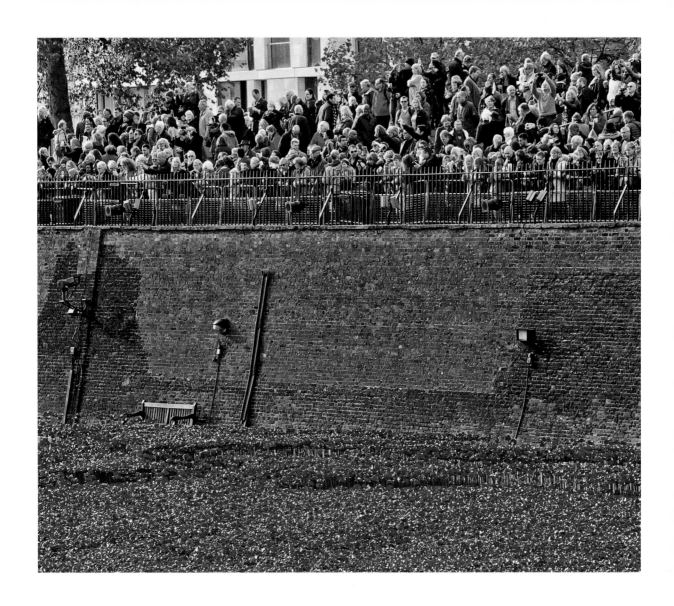

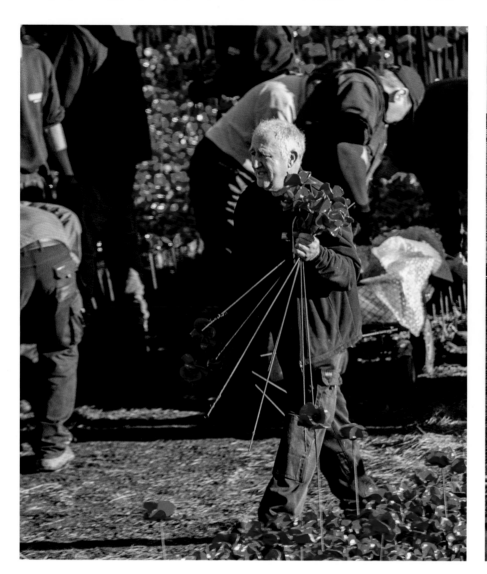

Blood Swept Lands and Seas of Red
remained complete for only one
day. On 12 November, work began
to remove, clean and send each
poppy to those that purchased
them. The artwork, which took four
months to build, was removed in
two short weeks by another army
of volunteers. *Wave* and *Weeping
Window* would remain at the Tower
of London until late November,
before embarking on their tour
across the UK the following year.

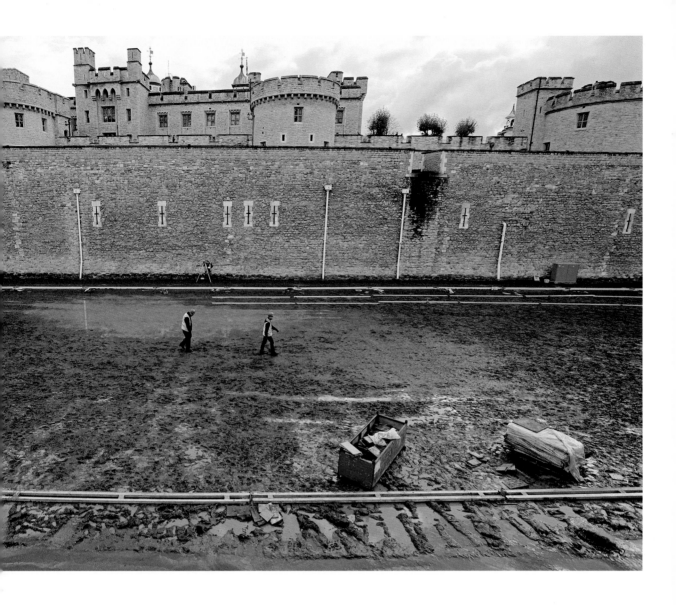

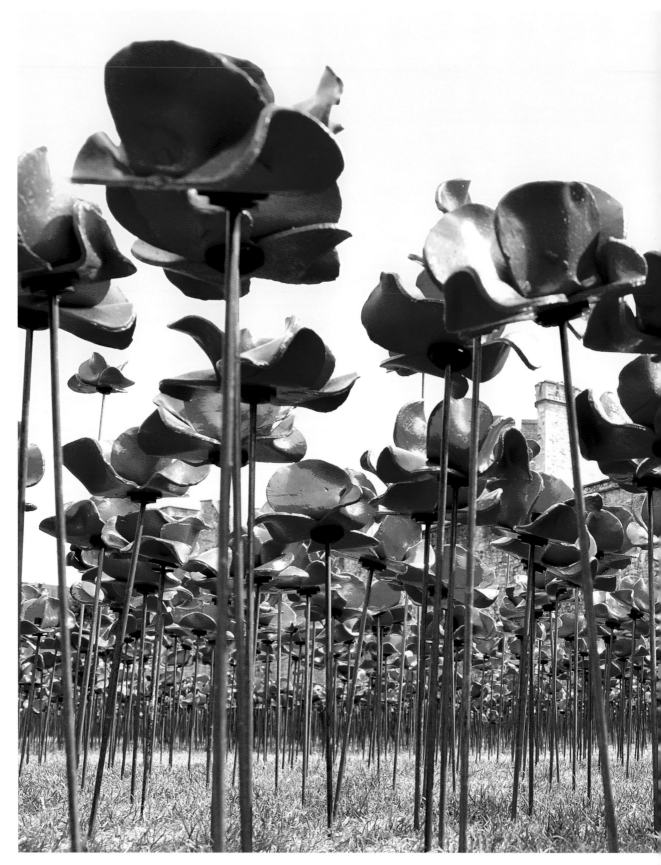

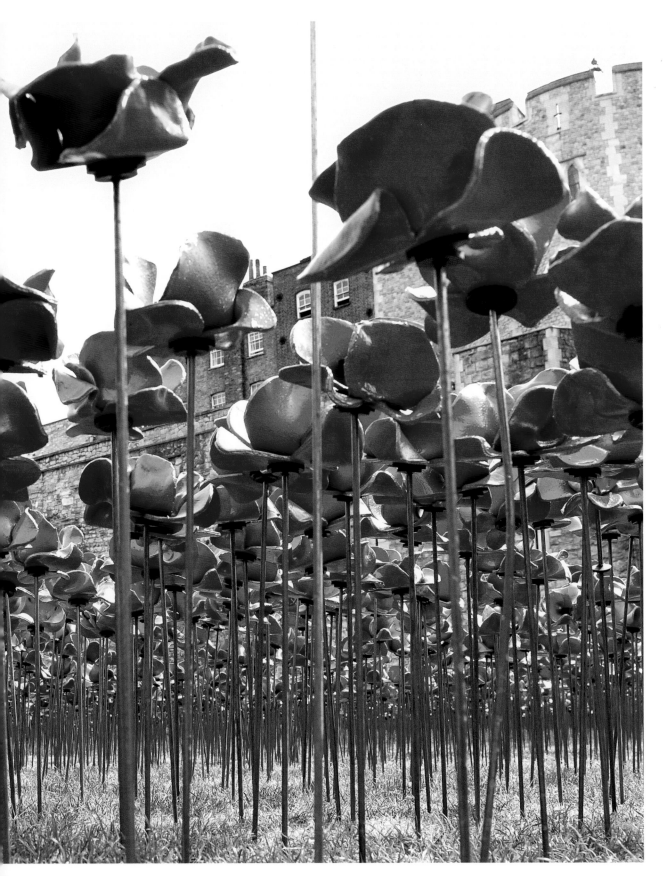

The Tour

September 2015–November 2018

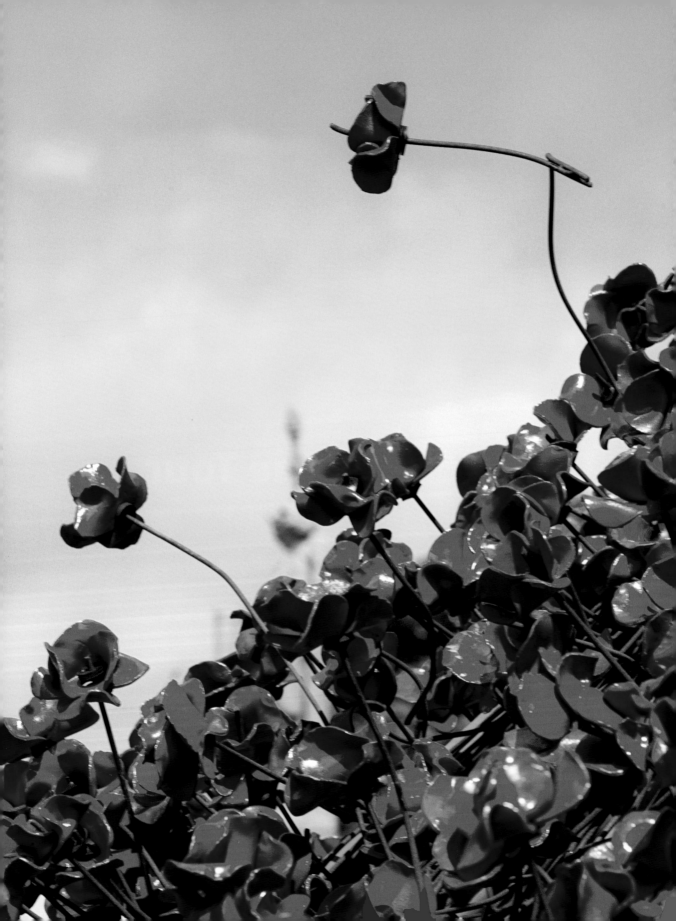

14-18 NOW

A note from the organisers

14-18 NOW launched in 2014 as the UK's national arts programme for the First World War centenary. Our ambition was to find new and powerful perspectives on one of the most devastating conflicts in history, giving people a stronger understanding and a closer emotional connection to a period that can sometimes feel remote from our 21st-century lives. Working with over 200 artists and more than 300 cultural organisations, 14-18 NOW's five-year programme reached more than 30 million people around the UK through everything from performances and exhibitions to books and films – plus major participative works such as *We're here because we're here*, Jeremy Deller's astonishing living memorial to the Battle of the Somme.

The public reaction to *Blood Swept Lands and Seas of Red* at the Tower of London in 2014 was both extraordinary and overwhelming. The work by artist Paul Cummins and designer Tom Piper was originally created as a one-off installation, but its reception in London made it clear that this was a story that deserved a second chapter.

The continued public life of the work was made possible by the remarkable generosity of two philanthropic organisations. When the poppies from the original installation were sold in 2014 to benefit six military charities, Susie Sainsbury's Backstage Trust and the Clore Duffield Foundation bought *Wave* and *Weeping Window*, two major sculptural elements from the work, and then gifted them to Imperial War Museums

and 14-18 NOW. This gift allowed us to develop our plans to take the poppies on tour, and we soon began inviting proposals from venues and organisations around the UK.

Beginning in September 2015 at Yorkshire Sculpture Park and ending three years later at IWM North and IWM London, 14-18 NOW's tour of Wave and Weeping Window visited 19 locations, each with their own unique connection to the First World War. Presented with generous support from the UK Government, DAF Trucks, the Foyle Foundation and Mtec, the UK tour was seen by over four million people – approaching the number who witnessed the original installation at the Tower of London. The works have now been preserved for the nation as part of Imperial War Museums' permanent collection.

Art is a vital way of connecting us to our shared history and heritage. It engages our emotions and harnesses our empathy – and through remarkable works such as the poppies, we can better understand our past, appreciate our present and consider our future. My colleagues at 14-18 NOW and I are enormously grateful to all those who helped make our tour of these landmark works possible, and I hope that this book will help to keep alive the memories it created among all those who saw *Wave and Weeping Window* on their three-year odyssey around the UK.

Vikki Heywood
Chairman, 14-18 NOW

2015

Yorkshire Sculpture Park
Woodhorn Museum Northumberland
St George's Hall Liverpool

Yorkshire Sculpture Park Wakefield

5 September 2015–10 January 2016

We were thrilled to be the first venue to welcome *Wave* in 2015. As the UK's leading open-air art gallery, hosting the poppies was a fascinating experience for us. By siting *Wave* away from the military surroundings of the Tower of London, we presented the work as both art installation and place to reflect and share memories.

Timing was tight, so planning began immediately and frantically. While the 888,246 poppies had drawn record crowds to London, *Wave* is formed of around 5,000 ceramic flowers. We were curious to see how this would be received.

Press and social media coverage immediately revealed that *Wave* would be a big hit. We quickly made arrangements to welcome larger numbers, recruiting more volunteers, securing extra car park space through a deal with a local farmer and establishing relationships with local police and St John's Ambulance.

Then Chancellor of the Exchequer, George Osborne, visited the Park to see the installation of the poppies on 25 August 2015 and the exhibition was formally opened on 3 September. On the opening weekend, we welcomed more than 20,000 people, and visitor numbers remained well above average for the duration of the display.

The installation was sited in the middle of the Park on the historic Cascade Bridge. This was a mixed blessing. On one hand, it was a beautiful, unique setting. On the other, it was a challenge for some visitors of an advanced age or with limited mobility. Our 'Poppies Shuttle Bus' was a big help though, and our team worked hard to look after everyone, ensuring they all got the chance to see the sculpture.

As Remembrance Sunday and Armistice Day approached, we began planning for the large numbers of visitors expected on both days. For the first time ever, we made access to the Park by ticket only. This was an experiment, and we weren't really sure what to expect. It raised questions about access – how could we close the Park when a public footpath runs right through it? We spread the word through social media and the local press, and worked with the Highways Agency to signal the closure on surrounding roads. Both events were a success – there was good awareness of the events and the closure, and tickets sold out for Remembrance Sunday.

When the sculpture closed on 10 January 2016, over 340,000 people had experienced Poppies: *Wave* at YSP. It was a very varied crowd – some were lapsed visitors returning to the Park for the first time in several years, while for others, it was the prompt they needed to make their first ever visit. The popularity of the artwork led us to celebrate our best ever year in terms of visitor numbers – by the end of 2015–16 we had welcomed 700,000 people to the Park.

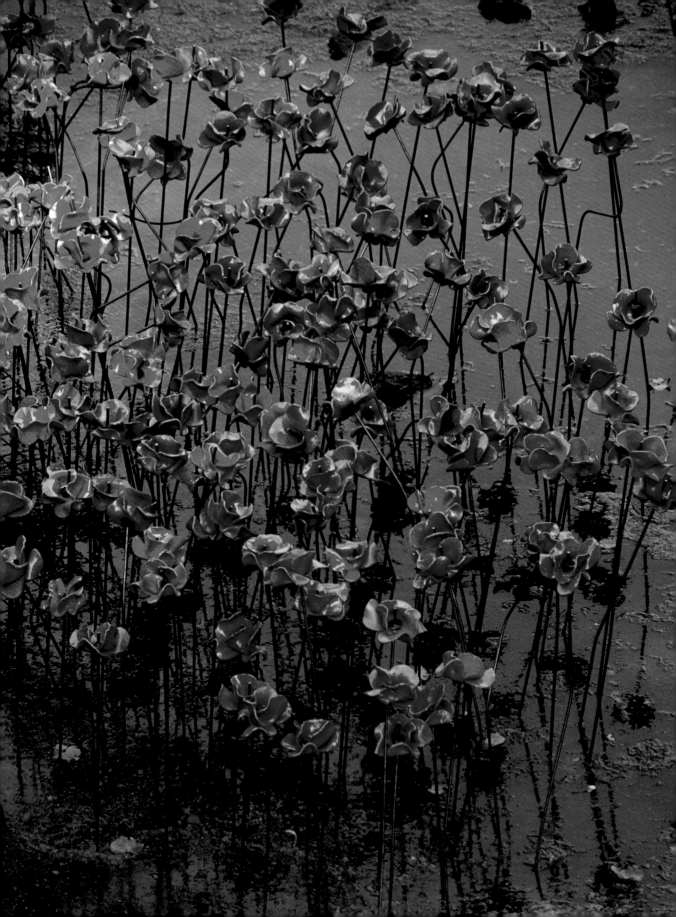

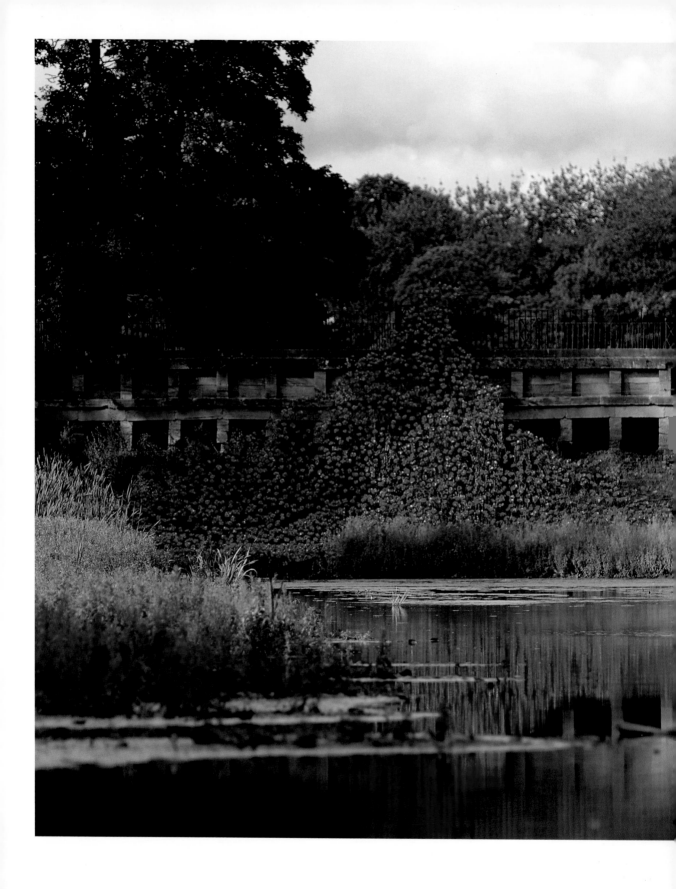

'The sculpture rose from the historic lake and was surrounded by 500 acres of stunning Yorkshire countryside and woodland. The calmness and nature of the Park offered visitors an ideal space for contemplation and reflection.'

Peter Murray CBE,
Founding & Executive Director,
Yorkshire Sculpture Park

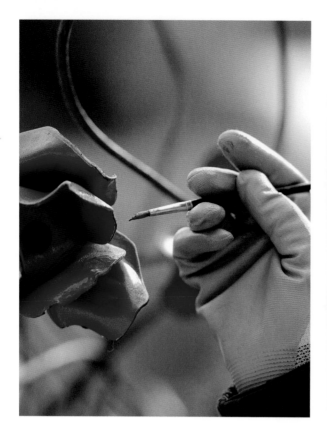

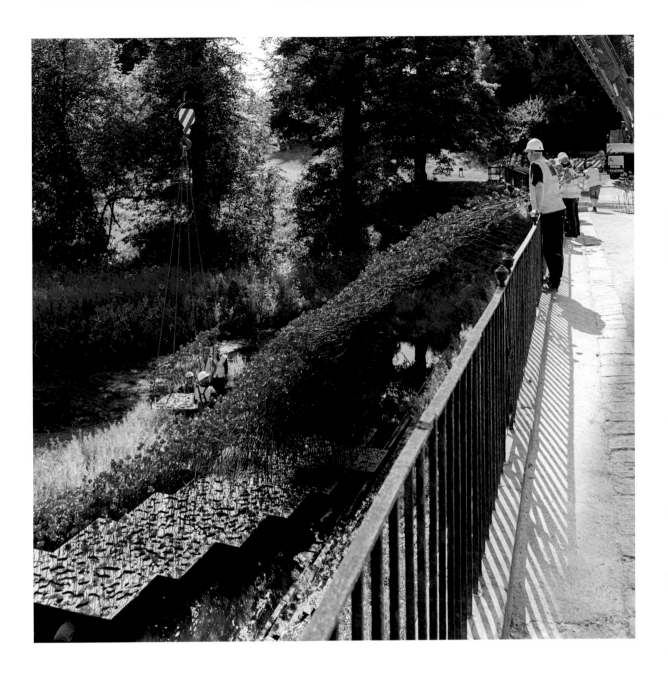

Woodhorn Museum Northumberland

12 September–1 November 2015

Woodhorn Museum, in Ashington, south-east Northumberland, was honoured to be the first venue to present *Weeping Window*.

At Woodhorn Museum's colliery heritage site, *Weeping Window* cascaded 55 feet from the winding wheel of the No. 1 Heapstead. The Heapstead – built in 1897 – is an instantly recognisable symbol of the industrial heritage of the North East region, and provided a dramatic new backdrop and context to the sculpture.

Woodhorn Colliery played a major part in the war effort. It was not only a leading producer of coal, but also supplied many skilled miners for the front. From the minute books of the Ashington Coal Company, which operated Woodhorn Colliery along with other collieries in the local area, we have established that, from a workforce of over 9,000, nearly 2,500 were serving within the armed forces and, by the beginning of 1917, around 250 had lost their lives.

Over 125,000 people visited *Weeping Window* during the course of its seven weeks on display at the museum. Exactly 47 volunteers contributed over 1,400 hours to support the presentation of the work and enhance the visitor experience. 12,000 people engaged with Postcards to the Past, an activity developed and led by artist Theresa Easton that offered visitors the opportunity to leave a creative personal response to the sculpture.

As the first tour venue for *Weeping Window*, Woodhorn Museum faced the challenge of only having a few weeks to plan and deliver the presentation of the work. Working closely with the 14-18 NOW team, our dedicated staff overcame obstacles ranging from securing the listed building consent required to install the sculpture, through to establishing the logistical infrastructure essential to safely manage an unprecedented volume of visitors through the museum site.

Our efforts were richly rewarded, not only by warmth of visitor feedback, but also through award recognition. We are very proud to have won 'Attraction of the Year' at the Living North Awards, 'Best Overall Event' at the Culture Awards and a special award for our wonderful volunteer team at the North East Museum Volunteer Awards.

Hosting *Weeping Window* was an extraordinary experience for everyone involved, and 'We need to think more poppies' is still used as a motivational phrase among museum staff today.

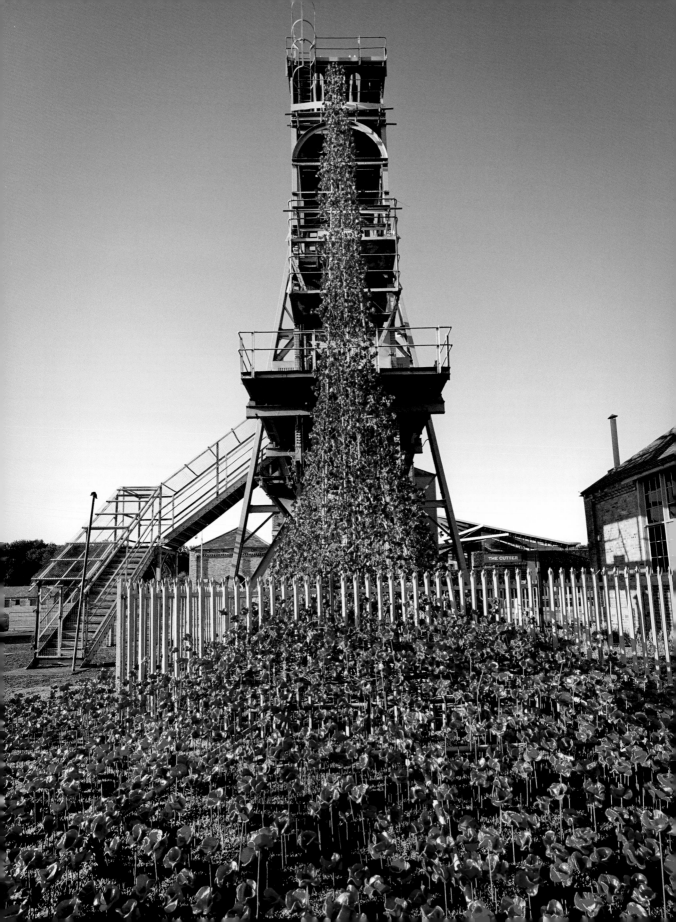

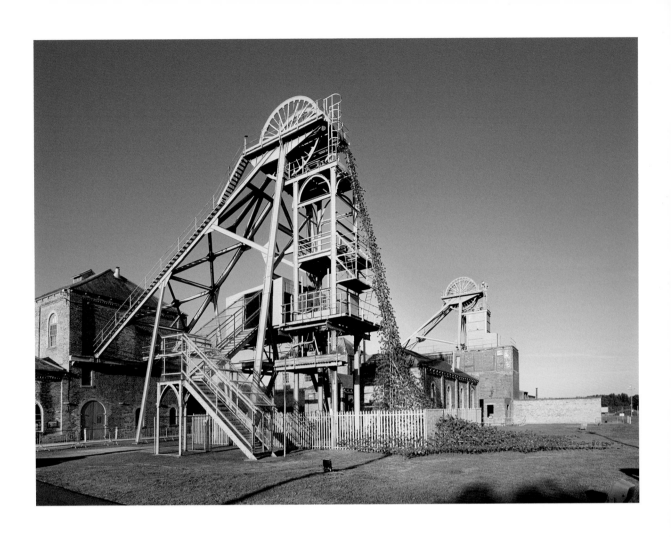

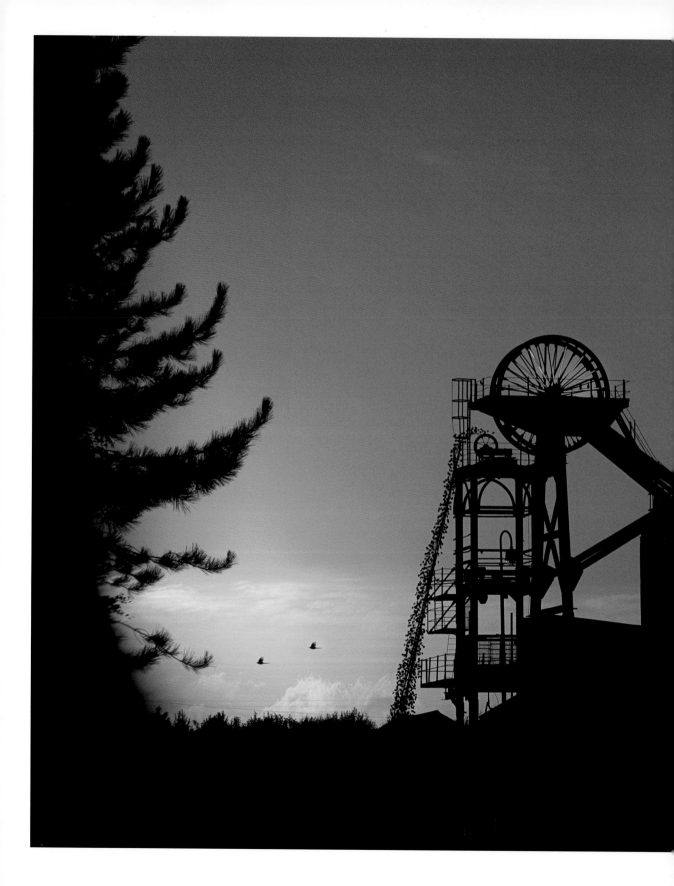

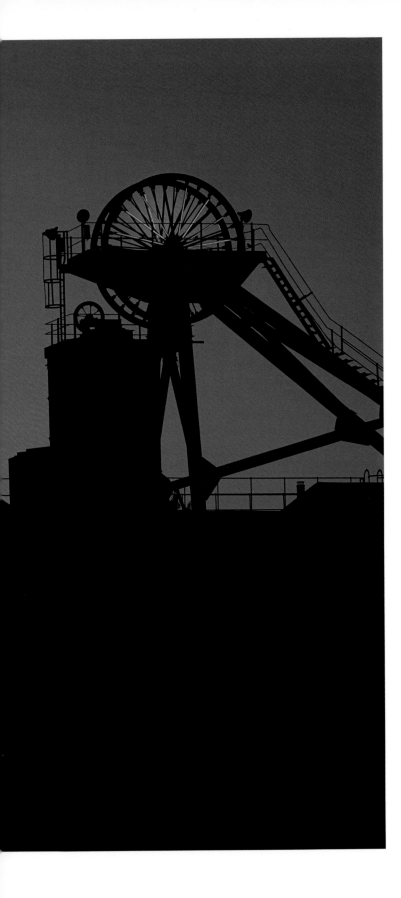

'The whole poppies experience was wonderful … if at times a tad emotional, especially listening to some of the stories that the public told me'

Poppies Volunteer

St. George's Hall Liverpool

7 November 2015–17 January 2016

From the moment it was announced that *Weeping Window* was heading to Liverpool it generated a buzz across the city. We had all seen this iconic sculpture in the original installation, which had created an unforgettable landscape at the Tower of London, and it was a privilege to know Liverpool would be its new home for a period of time.

The sculpture flowed down the façade of the Grade I listed St George's Hall – a location intrinsically linked with the First World War thanks to the role of the Liverpool Pals, which saw family members, friends, neighbours and work colleagues flock to the Hall to sign up and defend Britain on the battlefields of Europe.

Just steps away from where the poppies were displayed is the Grade I listed Cenotaph, a significant location and a focal point for the city, allowing people to come together as one in times of sorrow or celebration.

For 72 days *Weeping Window* became part of the fabric of the city and a staggering 360,000 visitors came to see the poignant artwork. Regardless of the elements, people travelled to the Hall – and although there were of course the obligatory selfies, the overriding response was for people to stand and look in awe at the wall of red in front of them in reverent silence.

Dozens of voluntary ambassadors were on hand to answer questions and talk about the installation, and in many cases they spent time chatting to people and listening to their own personal stories of how war had affected them. For many, talking to someone about their experiences was just as important as seeing the sculpture itself.

The arrival of the poppies coincided with Armistice Day in 2015. Liverpool is renowned for staging one of the largest Remembrance Sunday events outside of London, and to have the sculpture at the heart of the service was a huge coup. Its presence added gravitas for the 20,000 people gathered around St George's Hall on Sunday 8 November.

Visitors were always encouraged to comment on their experience engaging with the work. Feedback was received from hundreds of people, from 5 to 90 years old. They ranged from people simply stating 'stunning', 'incredible' or 'proud', right through to using the 'Time to Reflect and Remember' postcards available to pay personal tribute to family members who died or were injured during conflict.

There was, however, one common theme – these beautiful ceramic poppies had touched everyone. What could be regarded as such a simple symbol had a lasting impact.

Liverpool is a city which is no stranger to staging large-scale, thought-provoking events that attract hundreds of thousands of people. Hosting *Weeping Window* was no exception, however the pride it engendered in the people who live and work in this city was tangible. To this day, people remember this striking and emotive memorial – an unforgettable reflection on the human cost of war.

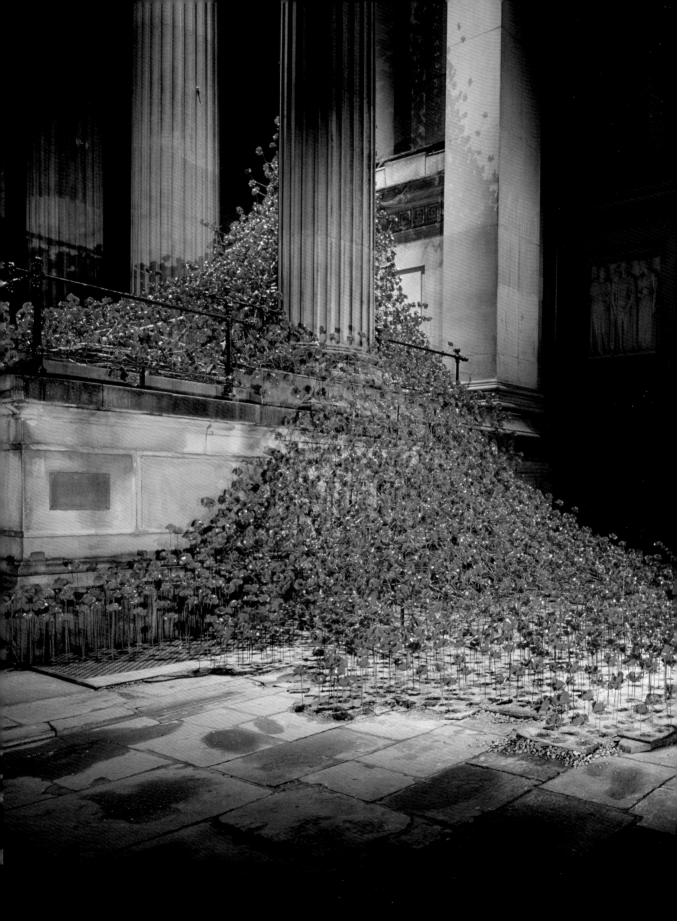

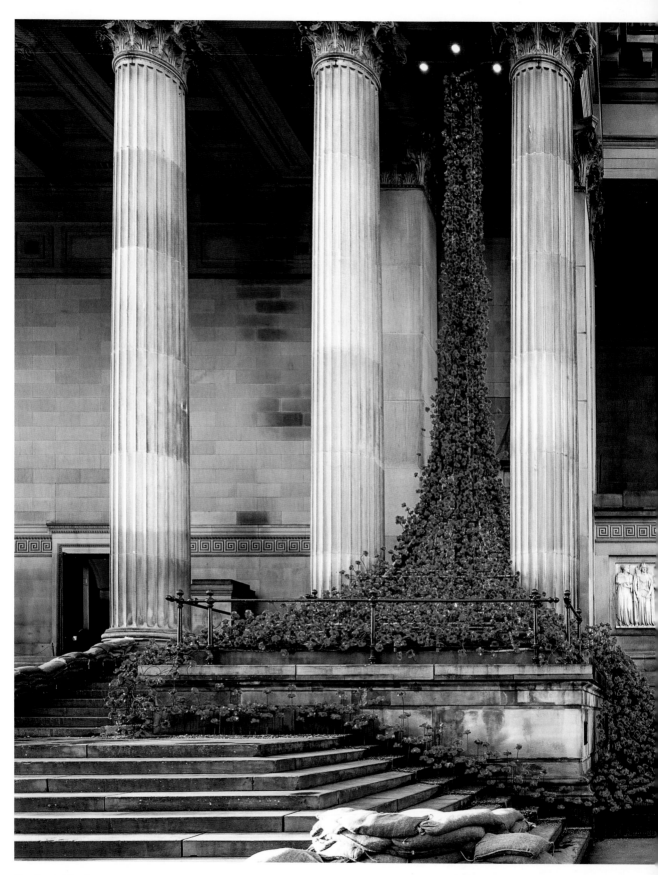

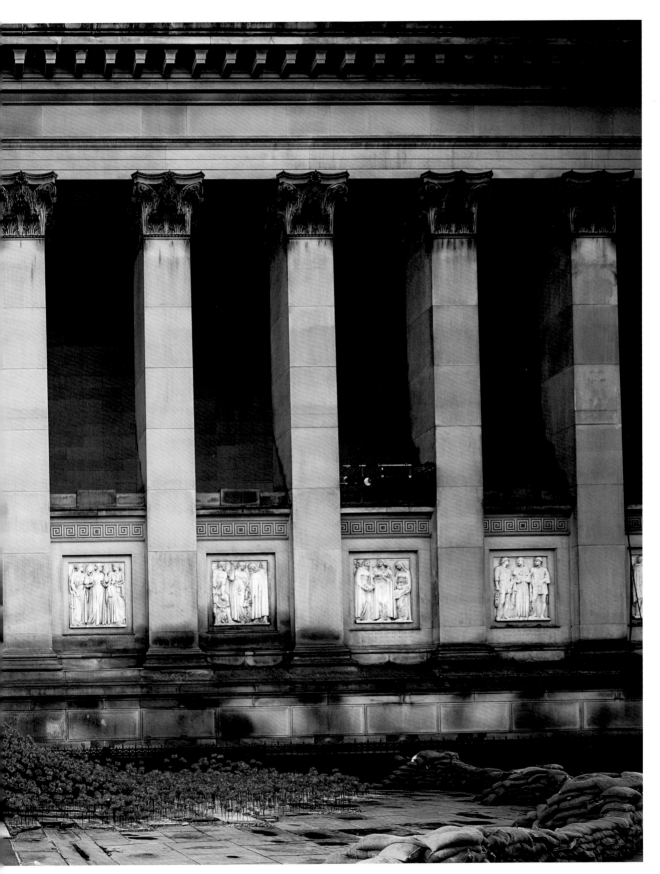

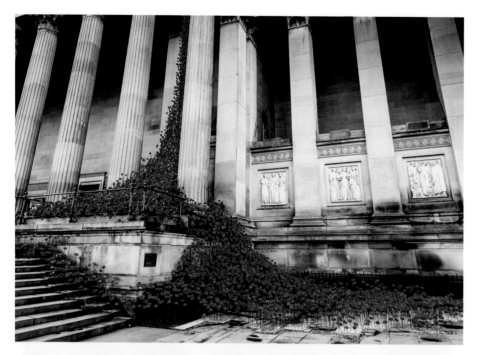

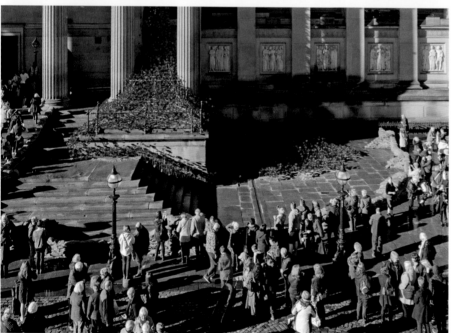

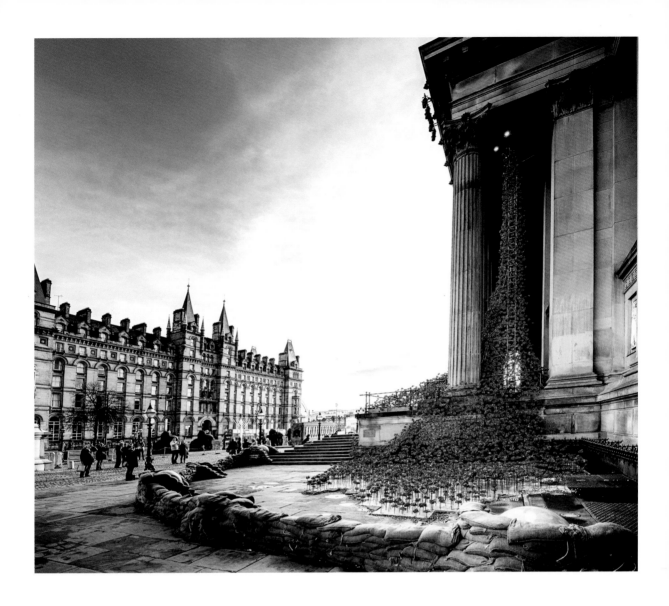

'The reaction to the stunning work has been overwhelming to say the least ... we knew that as usual, the people of Liverpool would come out in their thousands to show support for the thought-provoking piece of work.

Wendy Simon (Assistant Mayor)
Culture, Tourism and Events

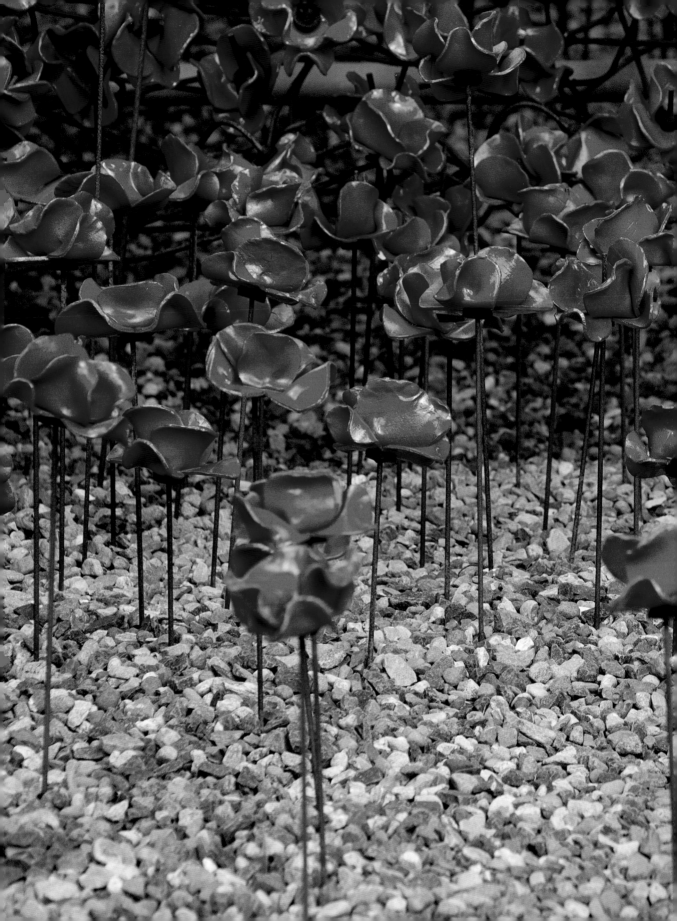

2016

St Magnus Cathedral Kirkwall
Lincoln Castle
The Black Watch Museum Perth
Caernarfon Castle

St Magnus Cathedral Kirkwall

22 April–12 June 2016

Orkney, the small archipelago of islands located off the North coast of Scotland, hosted Poppies: *Weeping Window* at St Magnus Cathedral, Kirkwall, between April and June 2016.

The sheltered water of Scapa Flow, one of the great natural harbours of the world, was home to the British Grand Fleet during both World Wars. Here, at the meeting of the North Sea and Atlantic Ocean, the islands commanded a strategic position vital to the Royal Navy and the war at sea. These turbulent waters witnessed many symbolic and tragic events during the First World War. It is therefore fitting that the sculpture provides such a poignant reminder of these and the lasting impact on the community and landscapes of Orkney.

Weeping Window was a central component to the national commemoration of the Battle of Jutland which took place in Orkney on the 31st May 2016. Services took place at St Magnus Cathedral and at the Lyness Royal Navy Cemetery on the Island of Hoy, close to where the Grand Fleet was fuelled and serviced. This marked the beginning of a week of community projects and events culminating in the centenary commemoration of the sinking of HMS Hampshire on the 5th June 1916 off Marwick Head in the West mainland of Orkney. One of those who lost their life was the Secretary of State for War, Lord Kitchener. A new memorial wall containing the names of all 737 men who lost their lives was unveiled alongside the Kitchener Memorial.

St Magnus Cathedral is owned by the people of Orkney. Founded in 1113 by the Viking, Earl Rognvald, in honour of his uncle St Magnus, the Cathedral is a reminder of Orkney's Norse heritage. Visually imposing and at the heart of Kirkwall's historic centre, the Cathedral was the obvious location to site the sculpture.

Given the historical significance of the building, the installation required a particularly sensitive approach. This was conducted by a small but skilled team of art handlers, museums and heritage staff and the Cathedral stonemasons — complemented by local scaffolding and building contractors. Despite some challenging weather conditions, the installation was completed ahead of schedule. Master stonemason Colin Watson retired at the end of 2016 and the project was a memorable way for him to conclude his time looking after this special building. Apprentice stonemason Sophie Turner was a vital part of the installation team and was awarded the CITB Scottish and GB apprentice of the year 2016.

The community's response to the sculpture was truly overwhelming; the arresting photographs of the poppies against the red sandstone went viral, within the county, nationally and internationally. What prevailed was a huge sense of pride that Orkney was able to host such a poignant symbol of reflection. This sense of pride was mirrored by 60-plus volunteers that came forward to act as custodians for the work over the 7 week period.

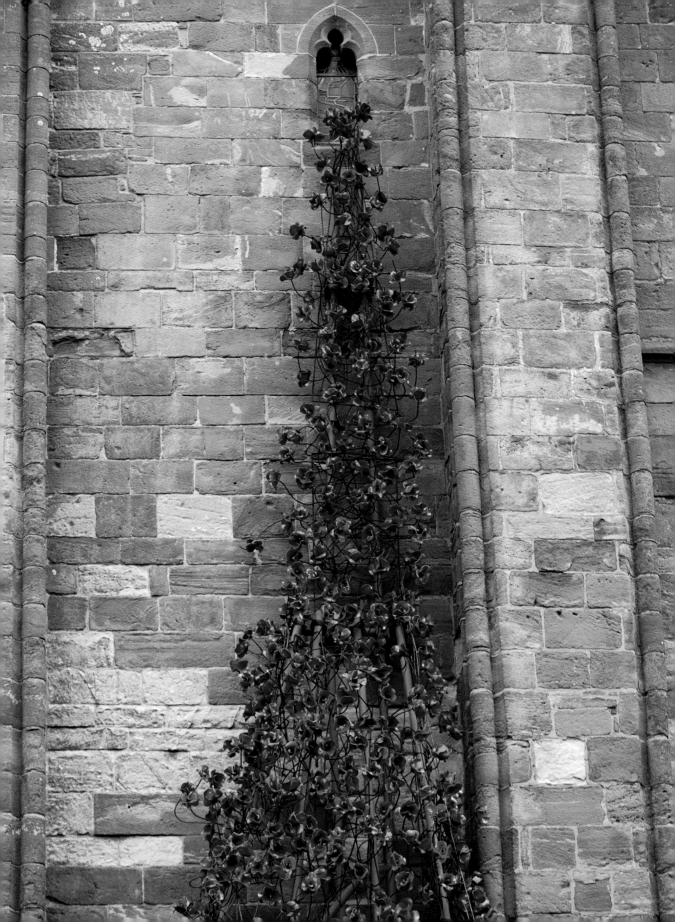

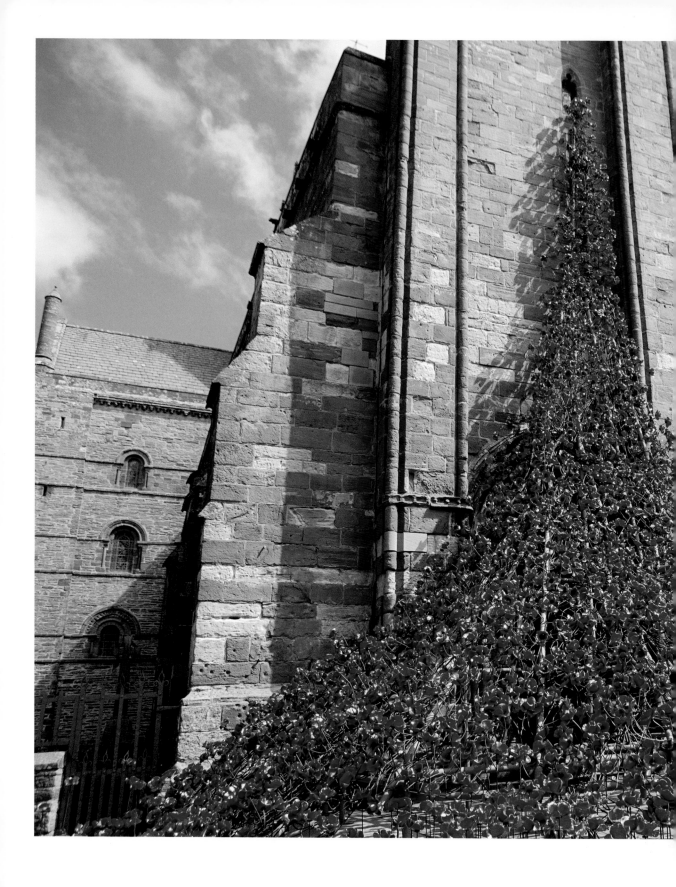

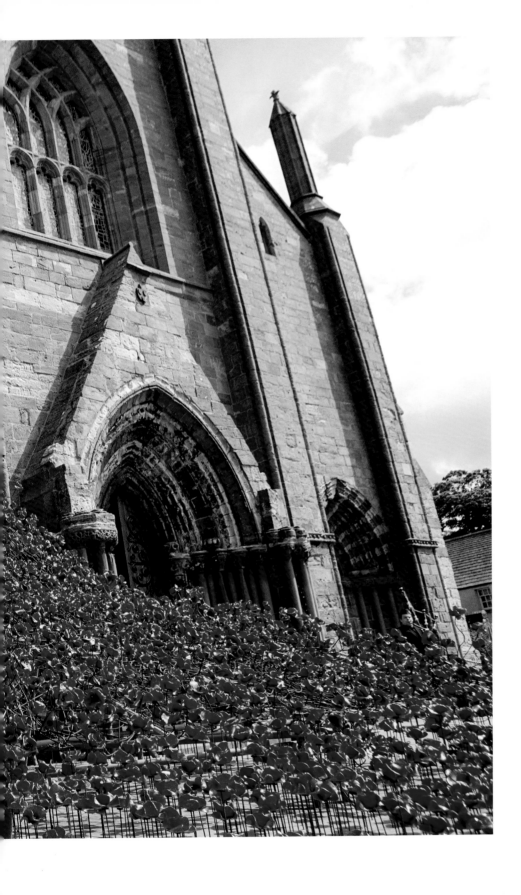

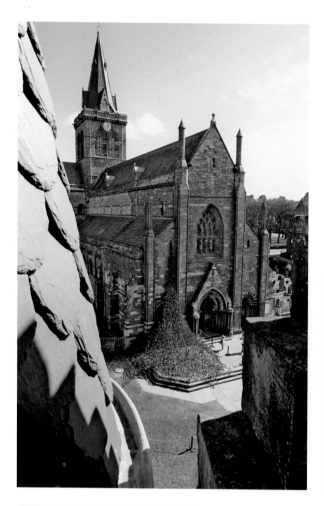
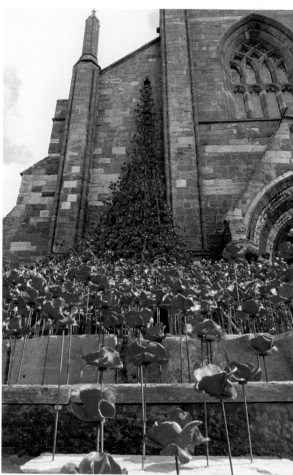

'I will always remember
the time volunteering
at the poppies. There
are so many wonderful
memories and
experiences.'

Poppies Volunteer

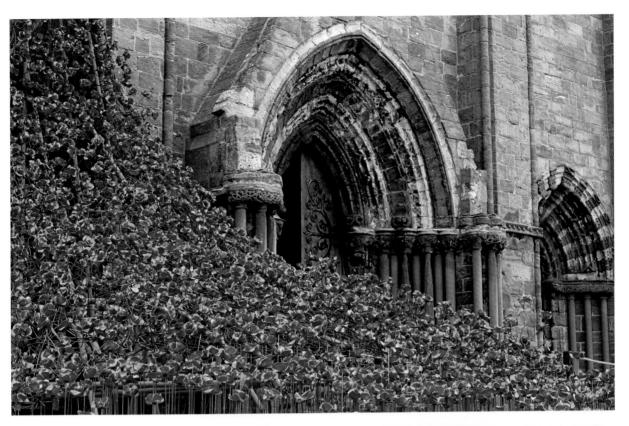

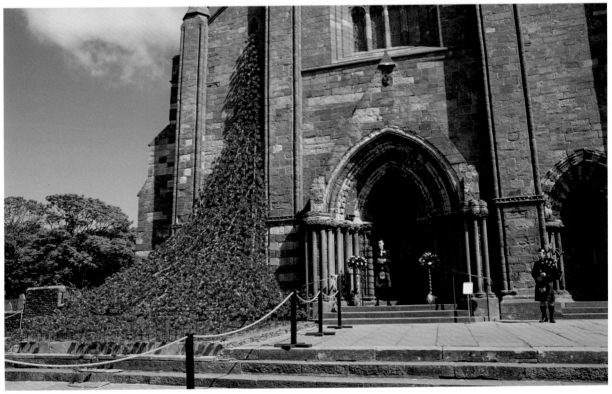

Lincoln Castle

28 May–4 September 2016

On hearing the news that Lincoln Castle had been selected as a host venue, we quickly assembled a team to assess the magnitude and complexity of the task. Working within a Scheduled Ancient Monument and adjacent to a working Crown Court presented more than a few challenges, but allowing over 500,000 visitors to witness the breathtaking sculpture made it all worthwhile.

Lincoln Castle was built by William the Conqueror in 1068, with the facing Lincoln Cathedral breaking ground in the decades to follow. They are probably the best surviving examples of the castle and cathedral combinations that William built up and down England, and they sit side by side on the skyline on the highest point of the Lincoln Edge, to be seen for miles around. The Castle houses a Victorian and Georgian Prison building and the county's Crown Court, built in 1845 and still in service today, within its walls and one of the four surviving copies of the 1215 Magna Carta, along with the 1217 Charter of the Forest, is available to view in a specially designed vault on the grounds.

Wave was positioned on the south-west wall of the Castle. The tall walls of the Prison and Castle curtain gave the effect of entrenching visitors as they arrived at the poppies viewing point, as the poppies themselves looked to be scaling the castle walls and at the top of their ascent, seemingly going 'over the top'. An incredible tribute to those who lost their lives doing just that 100 years ago. Comments left in our reflection space, within the Castle's 'Bath House', were moving, poignant and reflected not only the public desire for remembrance but also the civic pride in the city and county.

The Castle presented a compelling venue for *Wave*, especially considering the city and county's contribution to First World War. Lincoln, known as a centre of engineering, moved from manufacturing agricultural machinery to weapons and munitions. From 1915, William Fosters & Co. Ltd had been the primary government contractor for developing early tracked vehicles, resulting in the world's first operational tank, 'Little Willie', first used in action in 1916 at the Battle of the Somme. Lincoln firms were pivotal to the construction of the number of aircraft needed for the war effort. In 1914 the first aerodrome was established at Killingholme and by the end of 1918 the county was home to 37 military aerodromes.

The centenary of the start of the Battle of the Somme, where some 9,000 soldiers from Lincolnshire lost their lives, was marked at dawn on 1 July 2016 in front of *Wave*. Visitors were invited to join us for a ceremony involving the RAF Cranwell Band and Bugles, a flyover of historic aircraft and the presentation by 100 local schoolchildren who, guided by the learning team at the Castle, held aloft over 100 giant, hand-made poppies to create a very special 'Field of Remembrance'.

The continuity of remembrance is by far the most important legacy of Poppies: *Wave* and something the whole Castle team are immensely proud to have been part of.

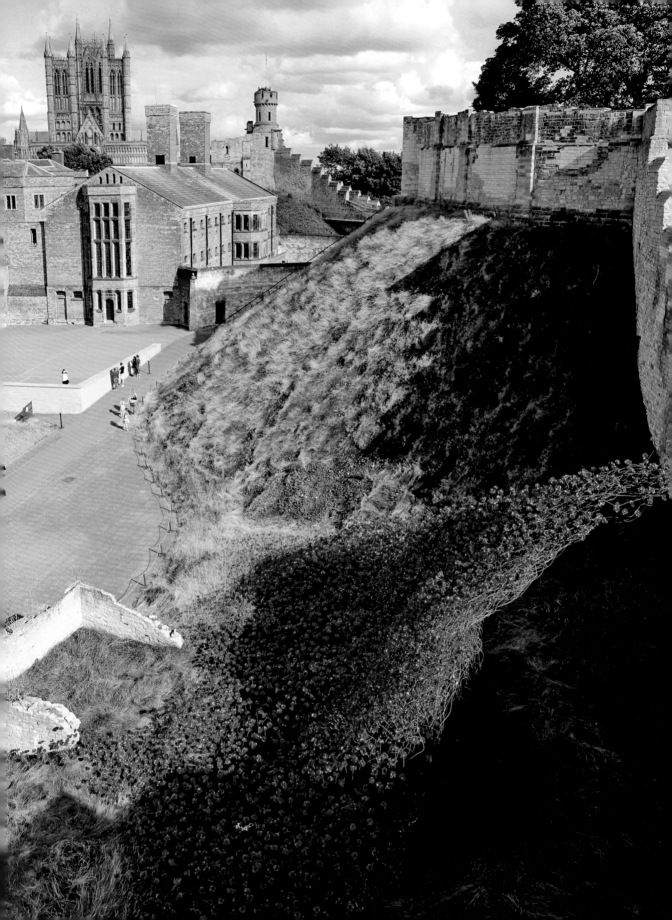

'The poppies united the city. Businesses and the local community engaged with their local history and had access to an iconic display within the Castle for free.'

Lydia Rusling
Chief Executive, Visit Lincoln

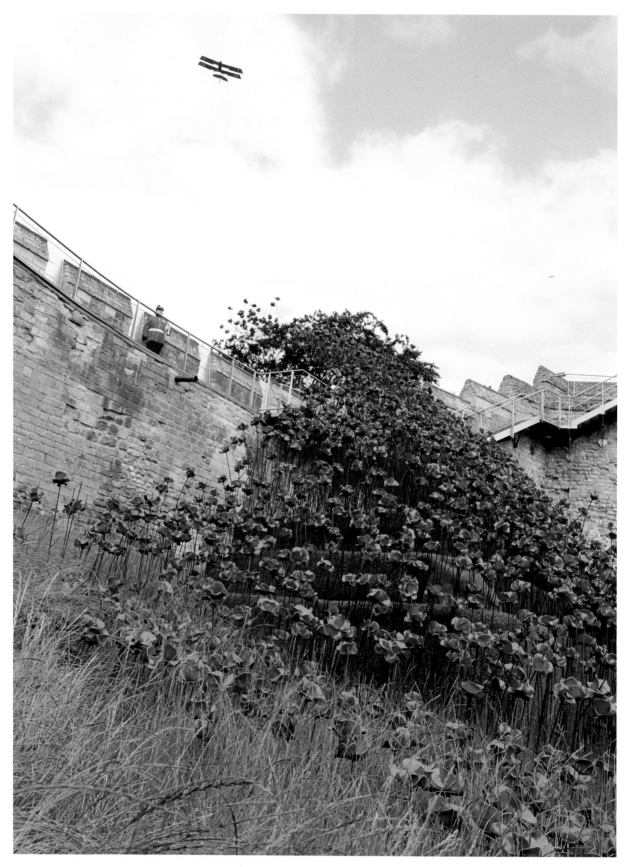

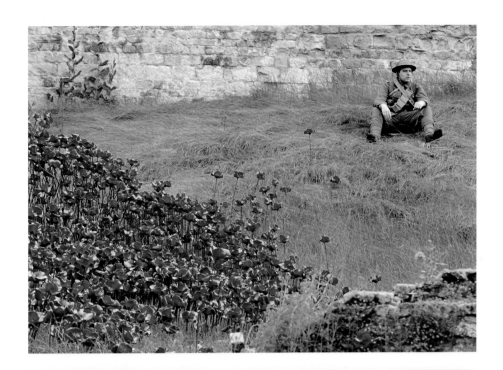

The Black Watch Museum Perth

30 June–25 September 2016

Balhousie Castle in Perth has been the regimental home of the Black Watch since the early 1960s. A major army re-organisation meant the Black Watch Depot at the Queen's Barracks was closed, and Regimental Headquarters and the museum came to the Castle where they remain to this day. During the First World War the regiment suffered loses of nearly 9,000 soldiers.

A historic Castle dating back to the fourteenth century is always going to have its challenges, however working as a team with the museum's staff, volunteers, the local council and the 14-18 NOW installation team enabled all to go well and, other than one day, the unpredictable, skittish weather was kind to us.

When we put out an appeal for help our army of Poppy Partners came to our rescue. Over 120 volunteers, aged between 16 and 81, arrived from the length and breadth of Scotland. We armed them with training, a bright red tee shirt and a waterproof jacket and they, alongside our staff, looked after our 120, 587 visitors with pride and passion. Our Poppy Partners had articles in the paper, their own interpretation panel, a blog and their own hashtag – #poppypartners.

On the 100th anniversary of the loss of any Black Watch Soldier we lay a cross on our memorial wall. On 25 September 2016, the final day *Weeping Window* would be seen at the Black Watch Museum, we lay 51 crosses to remember those who lost their lives during battle of Morval. One of those crosses was for Captain McLaren Stewart. His kilt can be seen on display in the museum's First World War gallery, still spattered with mud from the day he died. We managed to trace his family and, after viewing his mud-splattered kilt for the very first time, they laid his remembrance cross at our closing ceremony.

Hosting the sculpture at the Black Watch Museum has raised the profile of the museum to an international level. The feedback has been phenomenal. We have been honoured to be the first venue in mainland Scotland to host Poppies: *Weeping Window* and have been deeply humbled by the number of visitors who have travelled, not only from Scotland but across the world, to visit The Black Watch Castle and Museum to view the sculpture. Each visitor, in their own way, remembering, reflecting and paying tribute to those who have given their lives through war and conflict.

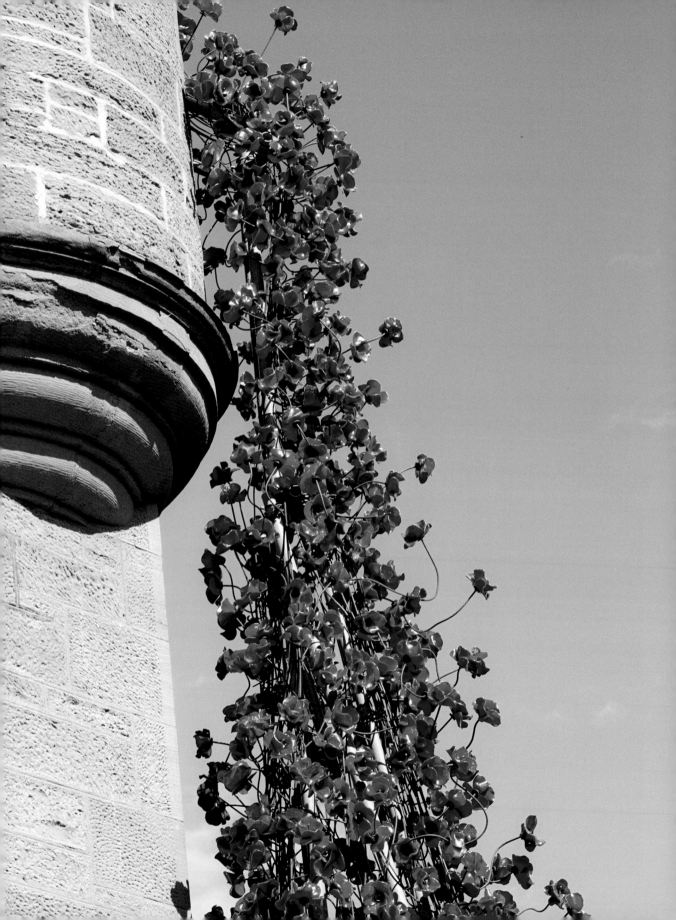

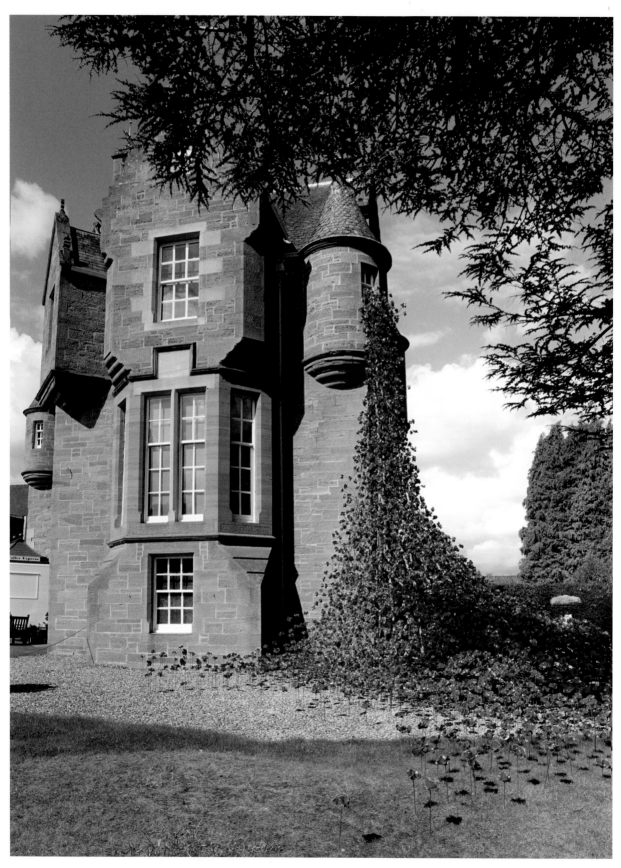

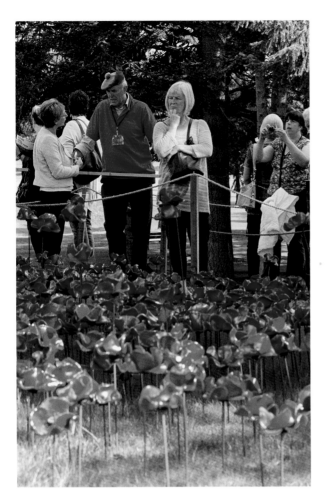

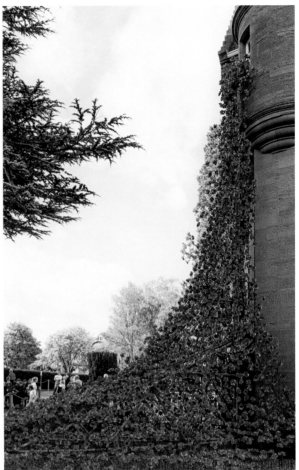

'To see the poppies arrive in quite a fragile and vulnerable state in their cases, only to be transformed into a strong and breath-taking sculpture is something that will stay with me for life.'

Anne Kinnes, CEO,
The Black Watch Castle and Museum

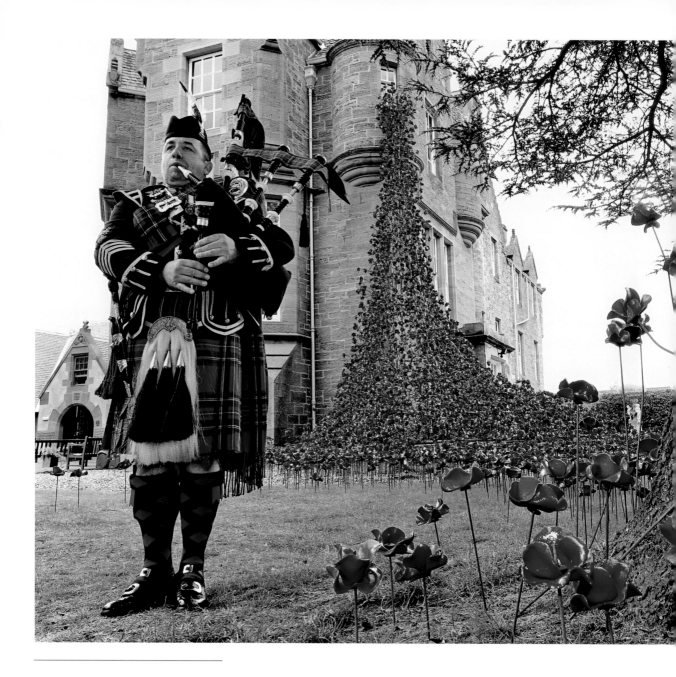

'It was a pleasure to
see this sculpture ...
a positive tribute to
the sacrifices the
poppies represent.'

Liz Grant
Provost of Perth and Kinross

Caernarfon Castle

12 October–20 November 2016

Caernarfon Castle, a medieval fortress begun in 1283 and located in Gwynedd, north-west Wales, was proud to be the first Welsh venue to host *Weeping Window*. A UNESCO World Heritage Site since 1986, it is cared for by Cadw, the Welsh Government's historic environment service. The sculpture cascaded down the side of the Watch Tower before flowing into the Upper Ward for six weeks in October and November 2016, marking both Remembrance Day and the centenary of the end of the Battle of the Somme, in which the Royal Welch Fusiliers played such an important role.

With extensive media coverage and amenable weather conditions, *Weeping Window* installation at Caernarfon Castle was an extraordinary success, and welcomed over 131,000 visitors over the course of the six weeks the sculpture was in situ, including over 400 school children. This extraordinary figure is a testament to the 49 volunteers who spent 1,400 hours creating an engaging visitor experience.

The North East Tower, adjacent to *Weeping Window* inside Caernarfon Castle, provided an intimate space where visitors could leave their own written reflections of the sculpture and First World War itself. Over the course of the exhibition over 4,500 reflection cards were collected.

While the sculpture was the centrepiece of the First World War remembrance plans, particularly around Remembrance Sunday and the centenary of the end of the Battle of the Somme on 18 November 2016, Cadw also worked closely with The Royal Welch Fusiliers Museum, which is housed inside the castle, to bring the temporary touring exhibition of the iconic Welsh Book of Remembrance to the site.

The Royal Welch Fusiliers Museum tells the stories of Wales's largest regiment, from the First World War up to the present day. This includes the story of notable poets, such as Siegfried Sassoon, Robert Graves and Welsh-language poet Hedd Wyn, who was killed on the first day of the Battle of Passchendaele in 1917. The Welsh Book of Remembrance lists, on 1,100 pages of velum, the names of 35,000 service personnel who lost their lives on the field of battle during the First World War.

To see the breathtaking *Weeping Window* at Caernarfon Castle was an incredible experience, and one that has had a lasting impact on everyone who worked so hard to make it a reality, and all those who came to witness it.

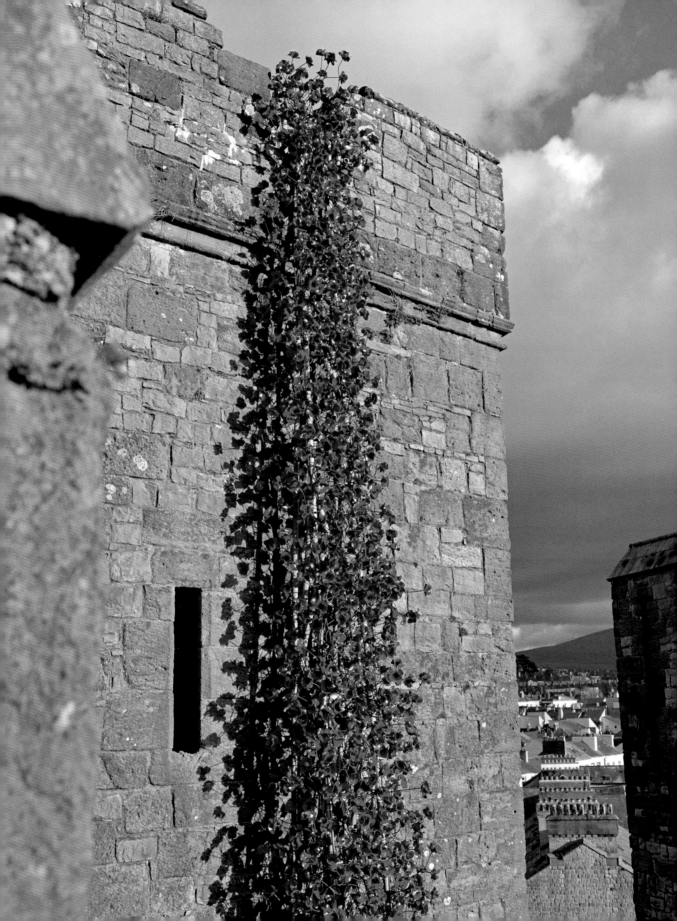

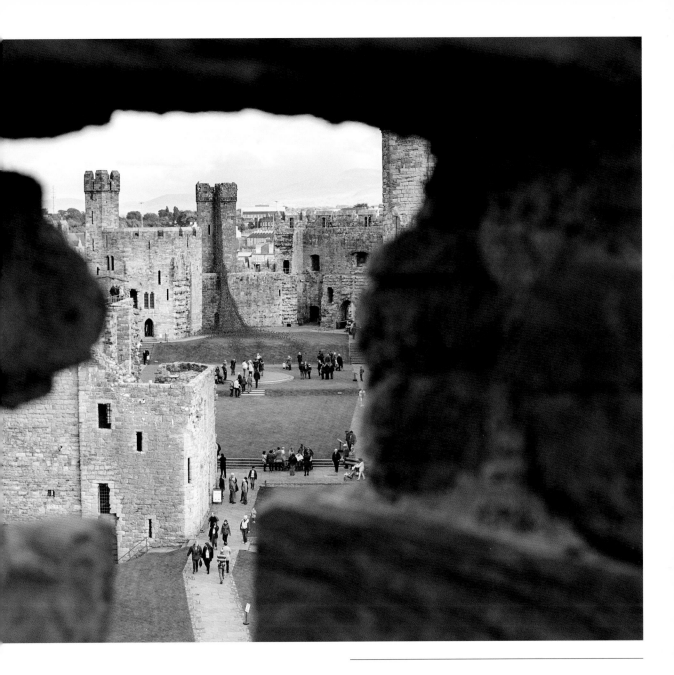

'I enjoyed finding out more about how people from this area contributed to the war ... It has made me want to find out a little bit more about what my grandfather's involvements were.'

Visitor

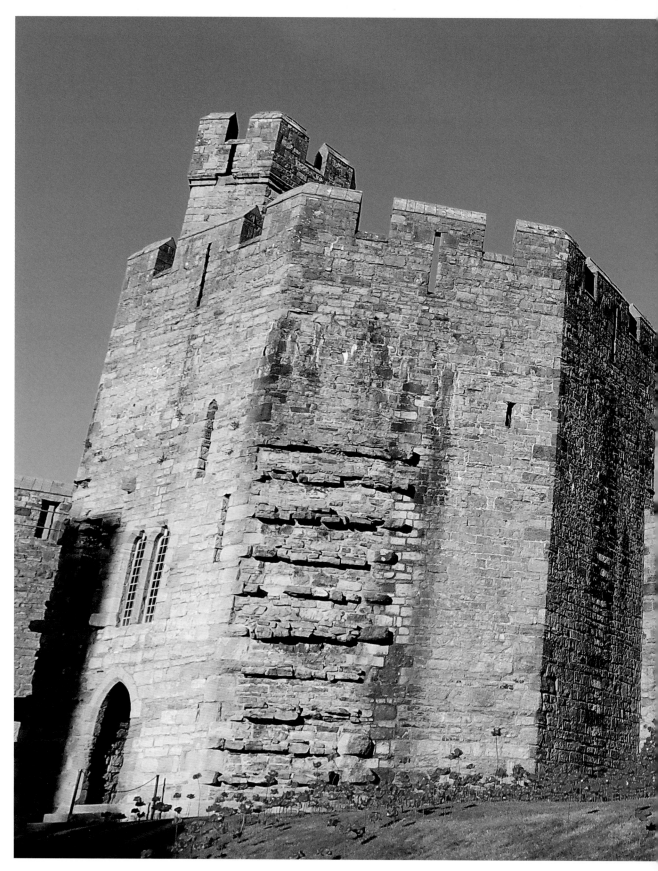

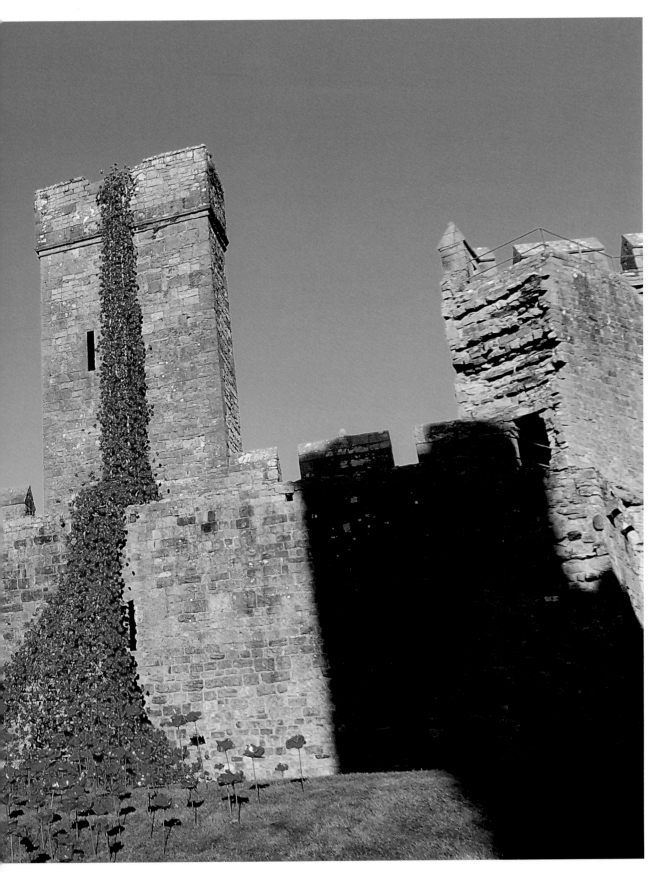

2017

Hull Maritime Museum
Barge Pier Shoeburyness
The Silk Mill Derby
The National Assembly for Wales
CWGC Plymouth Naval Memorial
Ulster Museum Belfast

Hull Maritime Museum

25 March—14 May 2017

In 2017 Hull achieved a worldwide prominence as UK City of Culture. For 12 months we enjoyed an unprecedented range of cultural events and activities, which touched everyone in the City.

Hull City Council and its cultural delivery company Hull Culture and Leisure Ltd wanted to bring *Weeping Window* to Hull during this ground-breaking year. Our choice of Hull Maritime Museum as a venue was intended to highlight the important roles played during the First World War by merchant seamen, and especially trawler men, from what was then 'Britain's Third Port'. The Museum, then the Dock Company Offices, bore witness to many of the city's experiences during the War, from the early recruitment drives across the square at City Hall, to the eventual victory celebrations. The timing, March to May 2017, was intended to commemorate the anniversary of the engagement at Oppy Wood, 3 May 1917, when the Hull Pals battalions of the East Yorkshire Regiment were decimated.

Site preparation began on 9 March 2017, with the official launch taking place on Friday 24 March 2017, attended by civic leaders, representatives from ex-servicemen's organisations, as well as 14-18 NOW and partners.

Weeping Window was one of the most striking and memorable events in Hull's City of Culture year 2017. The number of viewings is estimated to be in the region of 720,000 during the advertised opening hours. There will have been many thousands of viewings after hours, as the sculpture was installed on one of the busiest thoroughfares in the city centre. 720,000 views over 51 days — an average of 14,000 views a day — for any artwork has to be regarded as a remarkable success.

A key part of the success was the contribution of City of Culture volunteers whose enthusiasm and good humour enhanced the engagement of everyone who stopped to view the poppies.

Weeping Window is consistently cited as one of the highlights of 2017 by the people of Hull and the local press. The most frequently asked question was "Can we keep it?" The impact it made on individuals was huge. Many of them recorded their thoughts on reflection cards in a room we set aside in the Museum. Our hopes that people would remember seafarers who fought in the First World War were fulfilled, but many visitors were prompted to remember trawler men who had died in one of the most dangerous occupations in peace time; service personnel who fell in other conflicts; and loved ones who had passed away more recently. It introduced children to the concepts of conflict and death; visitors to the part Hull played in the War; and for the people of the City, *Weeping Window* was something for which to be proud of coming to Hull.

During 2017 the people of Hull came to believe passionately that art and culture can have a transformative effect in a city with many social and economic challenges, and people from outside Hull have seen what an allegedly remote and sometimes maligned city can achieve. *Weeping Window* made a huge contribution to this transformation. It will remain one of the defining images of Hull in 2017.

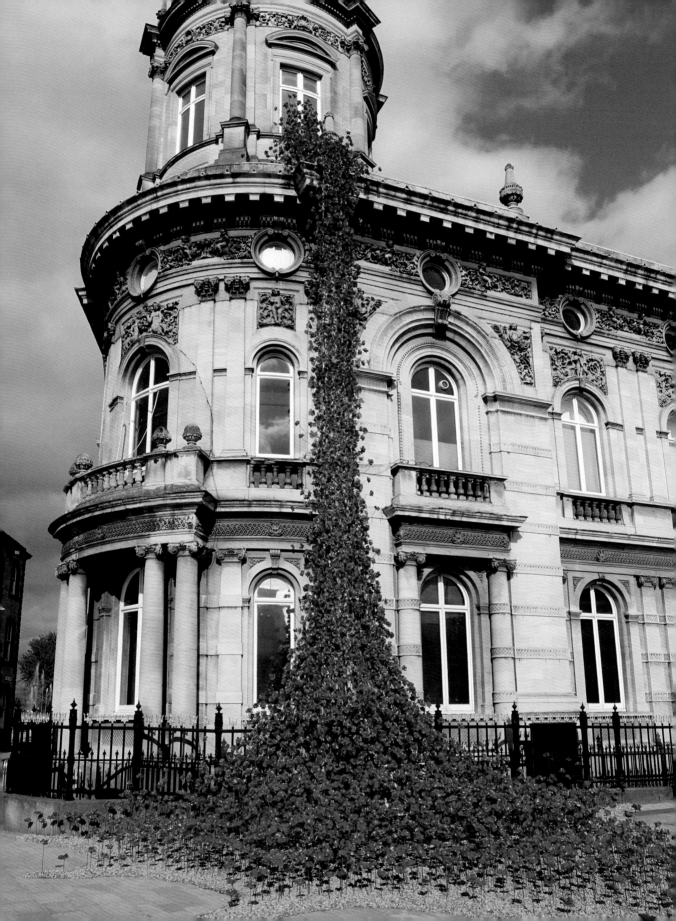

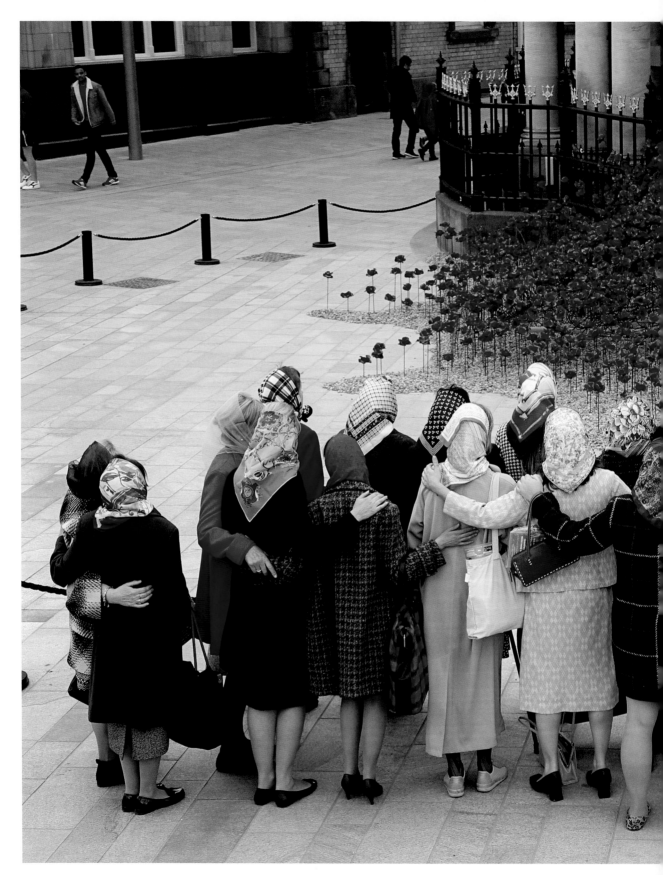

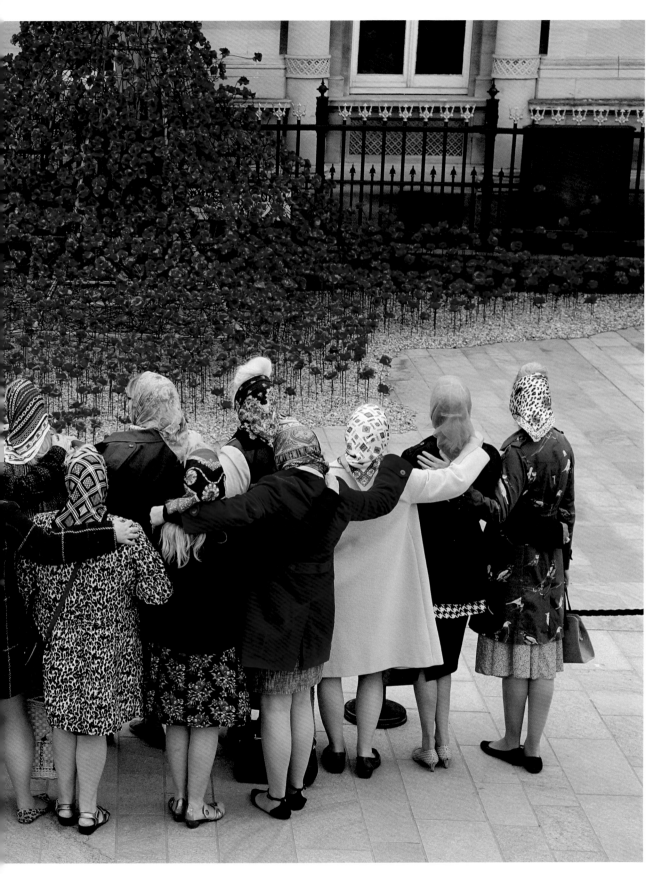

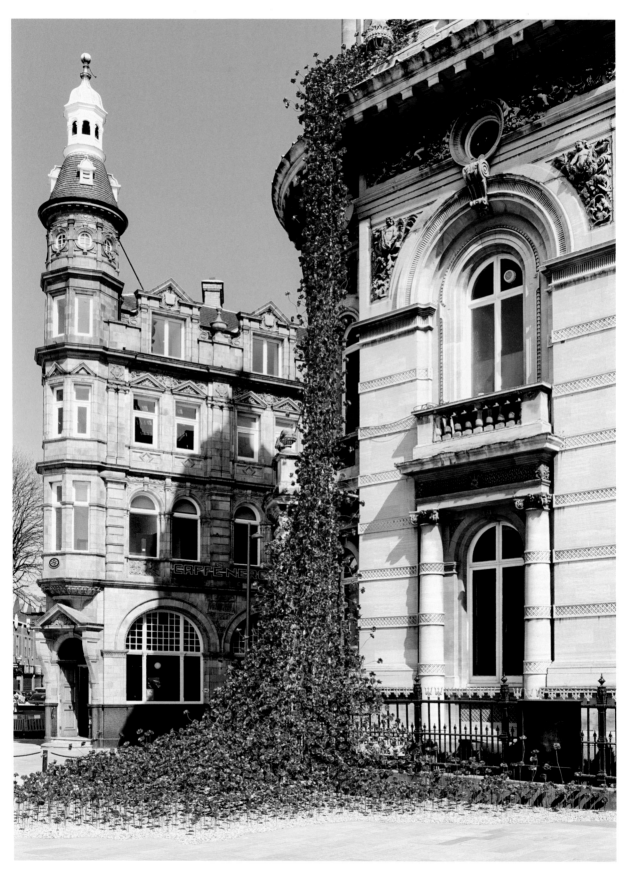

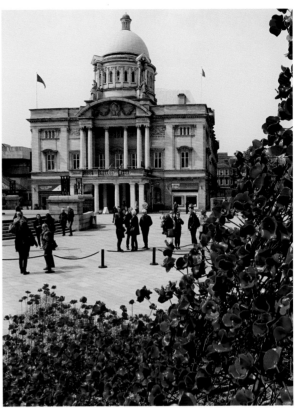

Barge Pier Shoeburyness, Southend-on-Sea

12 April–25 June 2017

During the spring of 2017, Barge Pier in Gunners Park, Shoeburyness was transformed into a visually inspiring platform to mark the centenary of the First World War. From 12th April until 25th June, the iconic Poppies: *Wave* sculpture rose up from Barge Pier to create a dramatic wave looking towards the Thames Estuary.

Barge Pier was constructed in 1909 and is believed to have been used for offloading munitions during the war. Southend-on-Sea was the scene of one of the first air-raid attacks on the UK during World War One and many of the artillery guns used during the conflict were designed and tested at Shoeburyness. Shoeburyness was also the site of the first British War Dog School, established in 1917, where dogs were trained and sent to France and Belgium, as well as serving as guards and sentries on the home front.

The location and condition of the pier presented many interesting challenges for the project team. The pier itself has been off limits to the public for many years due to being in a poor state of repair. Not only that, it is set within Gunners Park Wildlife area – adjacent to a Site of Special Scientific Interest – which meant a lack of utilities and access to clean drinking water. All the infrastructure required to build and host the installation had to be imported to site, however vehicular access was restricted due to both the terrain and the many dog walkers who use the site on a daily basis.

Despite all the challenges, Barge Pier proved a truly unique setting for *Wave*. Being situated on the estuary meant that the poppies took on different hues depending on the direction of the sun and whether or not the tide was in, presenting visitors with a different view every day. However, this also meant that they were exposed to all weathers – we experienced extreme cold, high winds, hail, intense sun and sand storms – everything but snow and thankfully no spring tides. Through all this our brilliant volunteers carried on with a smile and warm welcome for all the visitors.

More than 100,000 people visited Poppies: *Wave* at Shoeburyness. Local and international visitors alike were welcomed seven days a week by more than 190 Poppy Volunteers, who dedicated around 4,000 hours of their personal time to create a memorable and contemplative experience for everyone. As part of the outreach activity, we created a visual display of the many Memory Cards that were written by visitors – some did end up in the adjacent lake after a particularly windy day, only to be retrieved by our hardy volunteers.

More than 33 brass players, ranging in age from 10 to 90 years old, also volunteered their time to take part in a 75-day act of remembrance, performing a rendition of the 'Last Post' every evening at 7pm. Our closing ceremony was overwhelming and attracted over 3,000 visitors – we had estimated 300. We had specifically commissioned music for the occasion; theatrical performances and one last mass 'Last Post' event with 25 brass players of all ages.

Hosting *Wave* has raised the profile of Gunners Park – many of the borough's own residents didn't even know it existed and have discovered a truly remarkable area steeped in history on their own doorstep. Southend-on-Sea Borough Council is extremely grateful and thankful to everyone who helped make Poppies: *Wave* a huge success in Shoeburyness; it was an honour and pleasure for Southend-on-Sea to be part of something so very important.

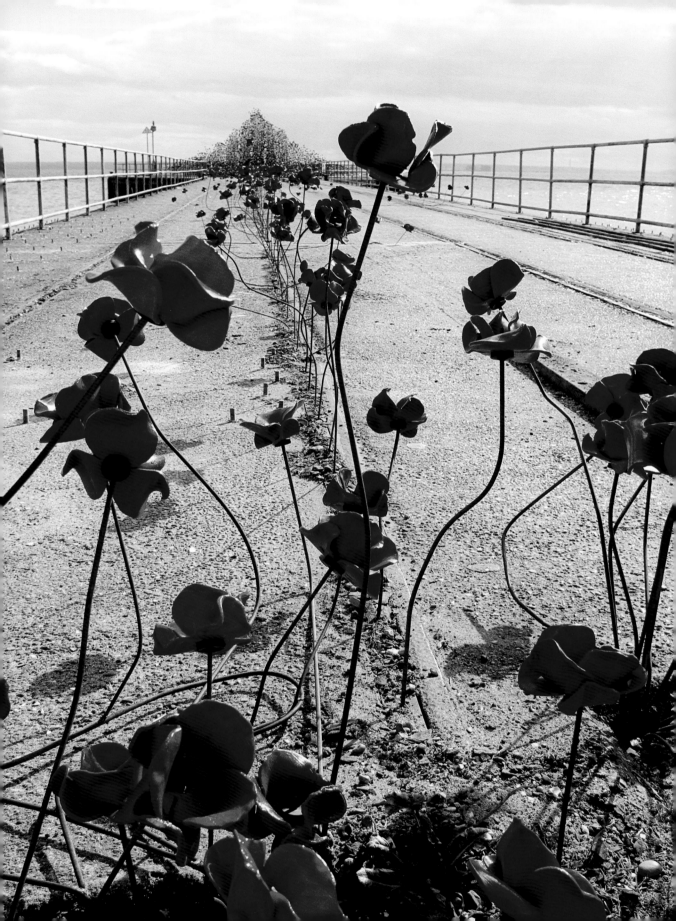

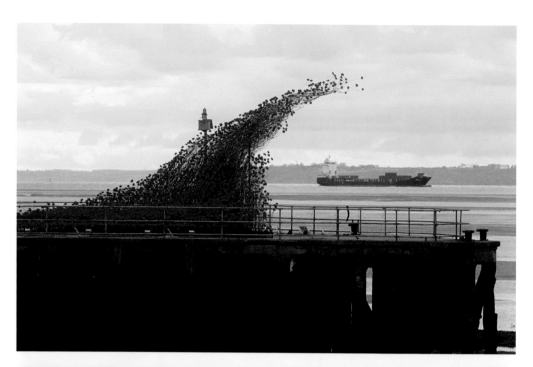

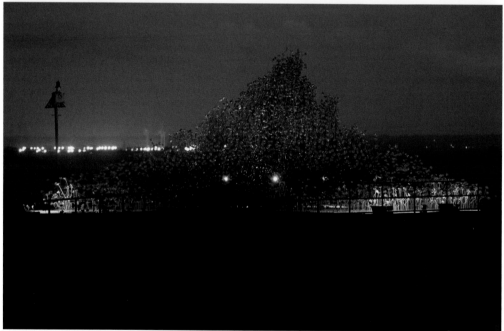

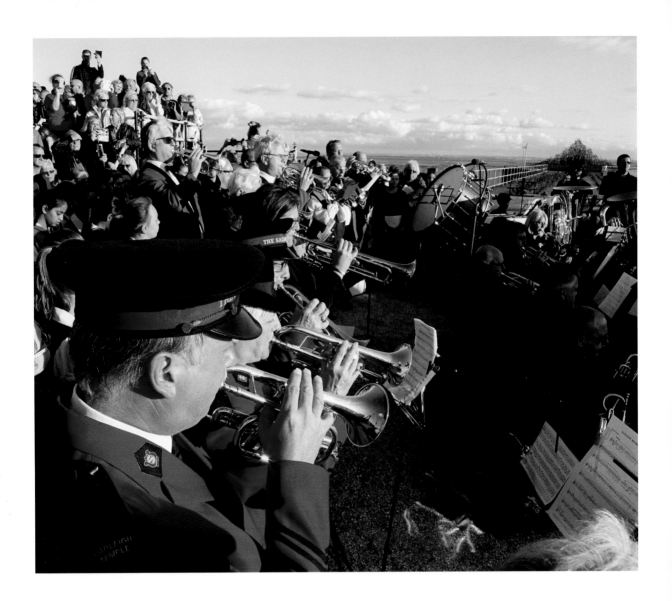

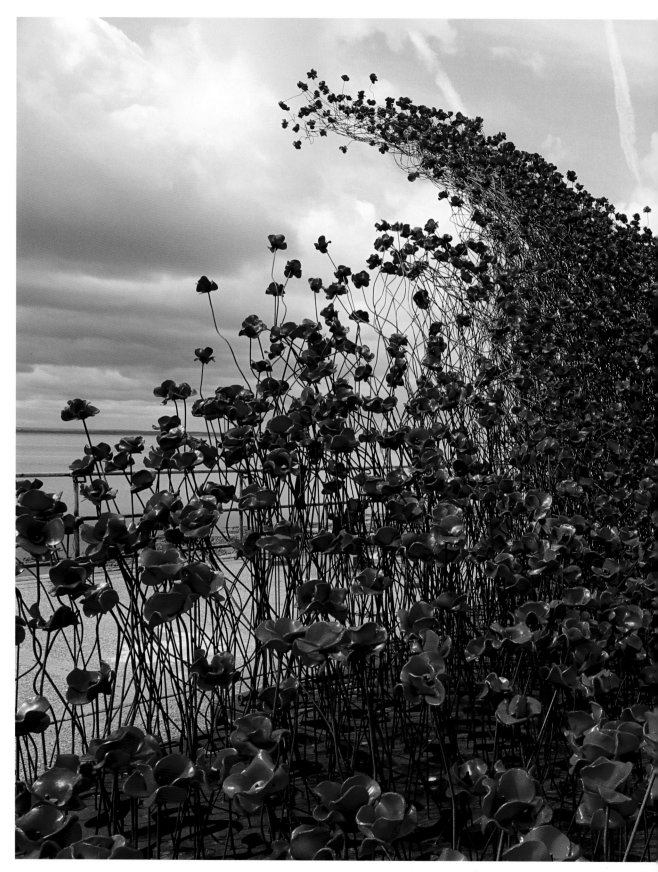

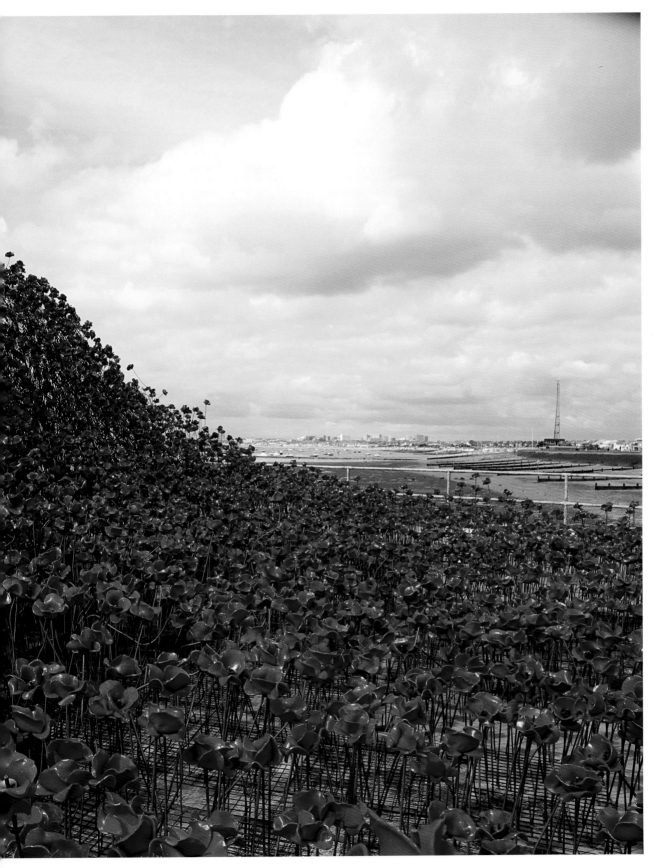

The Silk Mill Derby

9 June–23 July 2017

Derby Silk Mill is widely recognised as the site of the world's oldest factory and is part of the UNESCO inscribed Derwent Valley Mills World Heritage Site. The museum's location in Derby city centre, with the adjacent landscaped amphitheatre enabling people to sit, collect their thoughts and contemplate the meaning of the poppies, made it an ideal venue for *Weeping Window*.

At the time of the First World War the Silk Mill was home to 'FW Hampshire & Co Ltd', which produced powdered food and medicinal items. These were easily transportable to the front and the company became an important supplier in aiding the war effort. During the Second World War, the Silk Mill was used for fire watching and the tower proved invaluable in keeping the city safe from aerial attack. Barrage balloons were tied to the tower finials and the damage caused by the balloons, still visible today, remains a lasting memorial to its wartime use.

One of the highlights and challenges of installing the sculpture on one of the tallest venues of the tour was ensuring that damage was not caused to the Grade I listed building. However, it was also imperative that the presentation of the artwork was safe for the visiting public. It was a great achievement by the install team to make the supporting structure blend in with the building so that it did not detract from the view of the sculpture. This was done by hand painting the scaffolding to match the colour and texture of the building behind it.

Alongside Poppies: *Weeping Window*, the city came together to host a season of events and activities to commemorate the First World War including a digital trail, which covered the significant cultural and historical sites in Derby. Hosting the artwork unlocked stories involving Derby and its residents during the First World War, allowing all ages to explore their own and the city's connection to the conflict.

During the sculpture's time in Derby the Silk Mill welcomed over 200,000 visitors. The legacy of Poppies: *Weeping Window* will be felt by those visitors and volunteers who experienced the sculpture. Young people across the city were able to explore the themes and emotions evoked by the artwork as part of a dedicated schools programme. It has left a lasting impression in the minds of the thousands of people who witnessed it.

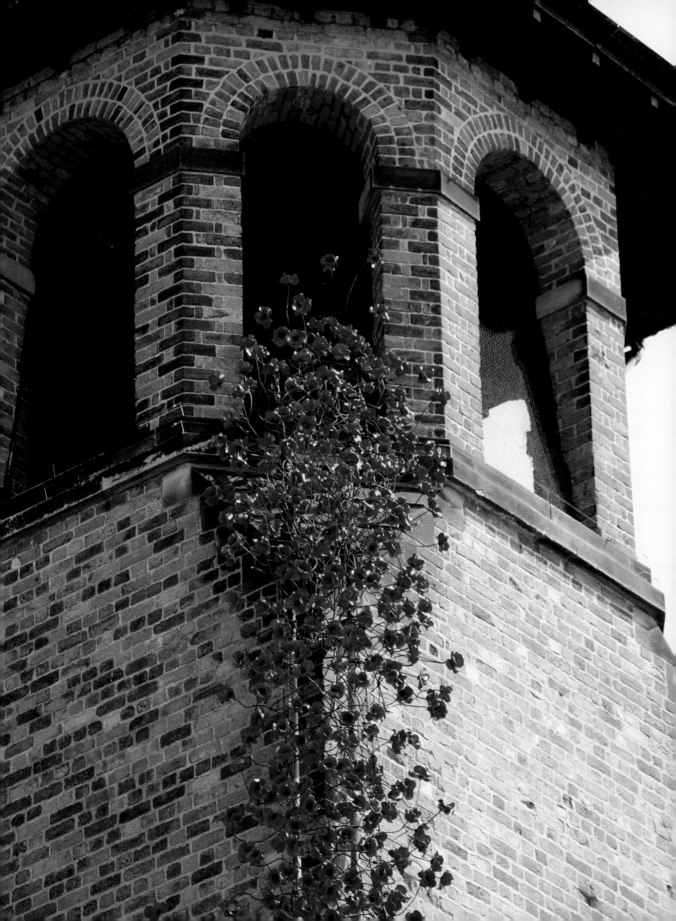

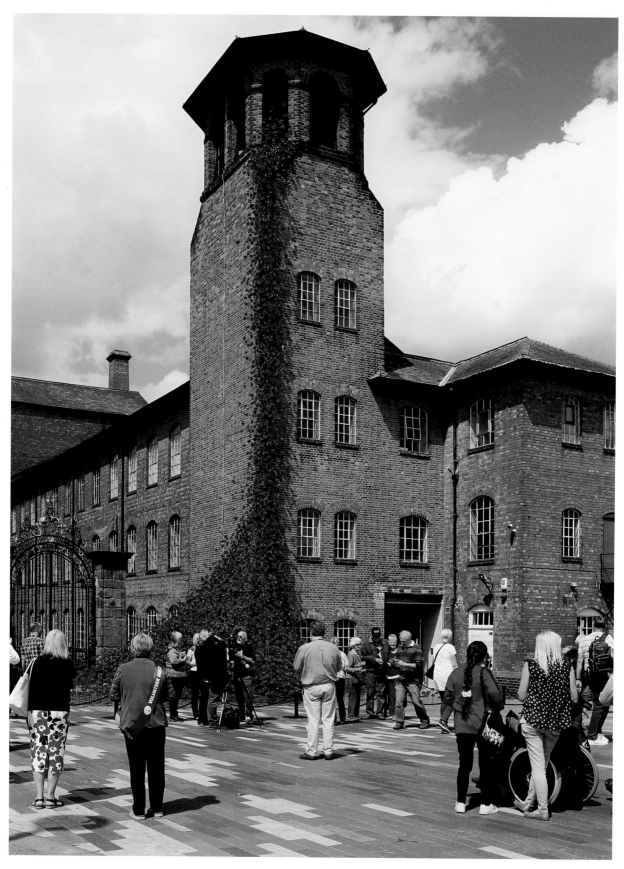

'I've been struck by the reverence and quiet contemplation which every visitor has shown. The notion that each poppy represents a life has really resonated and has been viscerally felt by visitors.'

Peter Ireson, Head of Culture, Events and Tourism at Derby Live

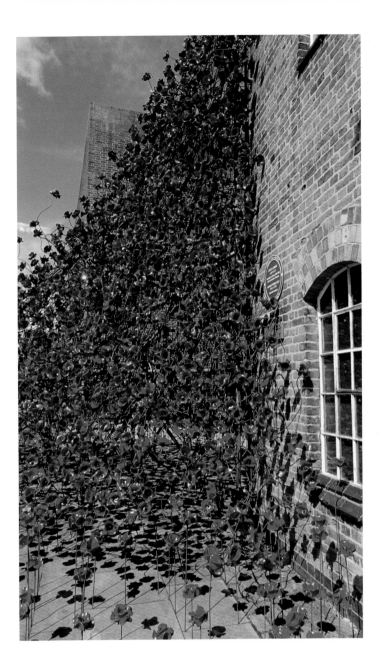

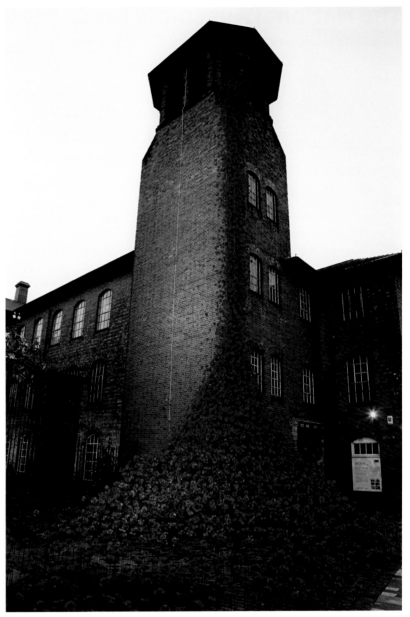

The National Assembly for Wales Cardiff

8 August–24 September 2017

The Senedd was chosen by 14-18 NOW as one of four locations for the 2017 leg of the Poppies tour, and was the only location in South Wales to present Poppies: *Weeping Window*. The home of Welsh democracy, the Senedd is where the 60 elected Members of the National Assembly for Wales debate issues that affect Welsh life. The modern building, which was designed by architect Richard Rogers and officially opened to the public in 2006, provided a great setting for the sculpture and reinforced the symbolism between past and future and between the sacrifice of those who lost their lives during the First World War and the freedom we can all enjoy today.

Buoyed by extensive media coverage, *Weeping Window* at The National Assembly's Senedd building proved incredibly popular, welcoming just under 85,000 visitors inside and outside of the building over the course of the 7-week presentation. This was an increase in visitor figures of over 440% compared to the same period year before.

This success was made possible by the hard work and enthusiasm of the 83 Assembly staff who took a short break away from their desks over the summer recess to become 'Poppy Partners'. Four of them worked for seven days with the professional art technicians to install the sculpture, while the others welcomed the thousands of visitors to the estate, engaged with them about the sculpture and ushered them inside the Senedd to see the sculpture at 360 degrees. People came from all over Wales and beyond to see the poppies, and shared with us many compelling stories about relatives who fought during the First World War.

To reflect the theme of the artwork, we worked closely with Welsh Centre for International Affairs' 'Wales for Peace' project to bring the temporary touring exhibition of the iconic Welsh Book of Remembrance to the Senedd. An interactive digital display allowed the public to search for a friend or family member by regiment. There was also an intimate space in the Chamber viewing gallery where visitors could leave their own written reflections of the sculpture and First World War itself. Over the course of the sculpture we collected over 675 reflection cards.

Our Education and Youth Engagement Team welcomed 11 schools from all across Wales after the summer recess, and worked alongside 14-18 NOW to create a Digital Storytelling Workshop for primary school children at a half day event on the steps of the Senedd next to the artwork. St Teilo's Primary school even produced a special poem for the occasion.

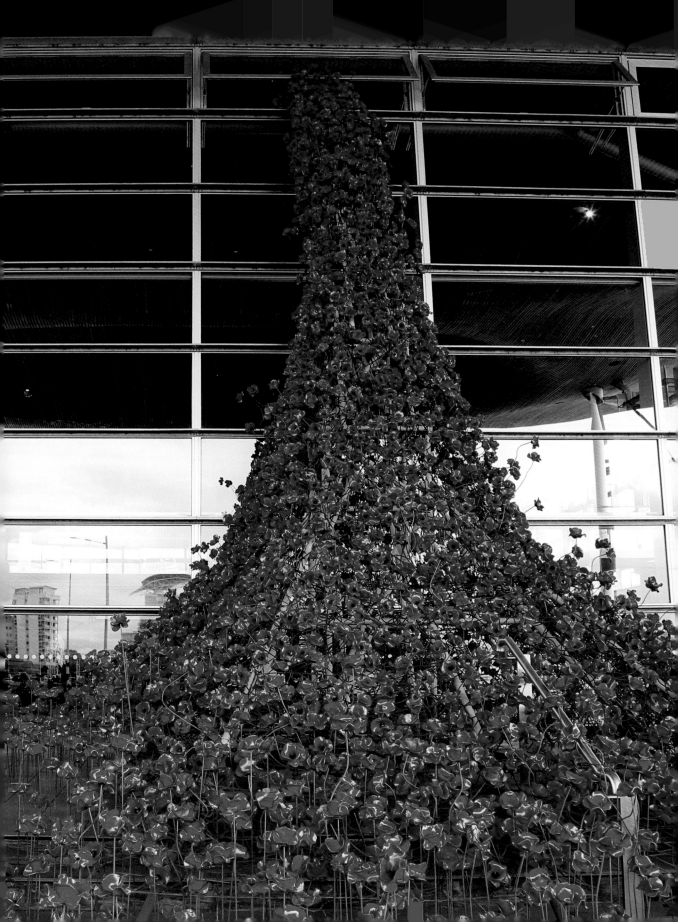

Rydym yn sefyll o flaen y pabis coch,
We stand before the poppies red

Llifo mae dagrau lawr fy moch.
And tears flow for those now dead.

Cofio'r arwyr a fu yn brwydro'n ddewr
Remembering heroes who battled, brave

Drosto ti a mi.
So that we could all be saved.

O un naw un pedwar i
Nineteen fourteen to

Un naw un wyth.
Nineteen eighteen.

Colli cyfeillion, ffrindiau a theuluoedd.
The loss of family and friends so keen.

Yna, gwelwch y gwynt
And when the wind does blow this way,

Mae'r pabis yn chwifio,
Watch those red poppies as they sway,

Mewn cynghanedd a sain
Dancing to their music's heed

Mae fy nghalon yn wylo.
As my aching heart does bleed.

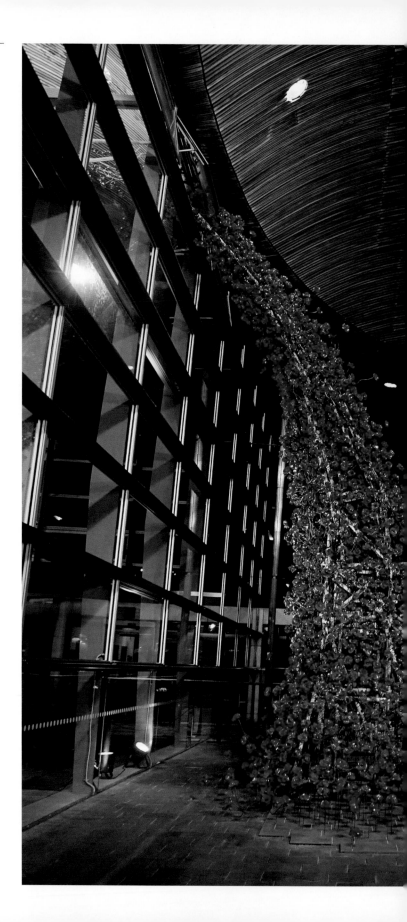

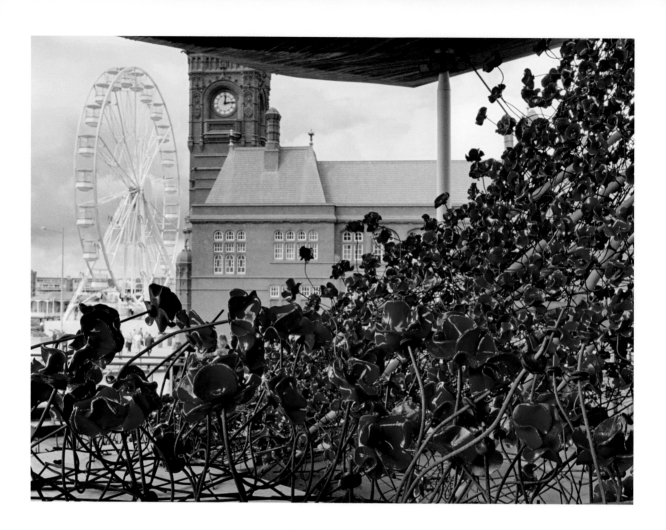

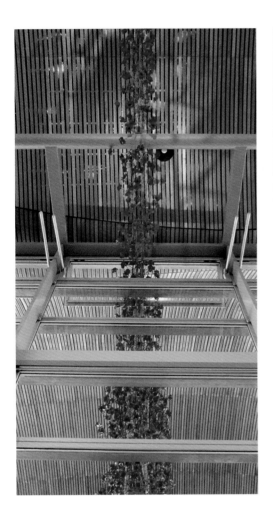
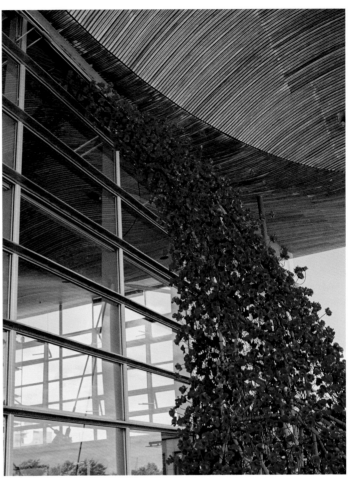

CWGC Plymouth Naval Memorial

23 August–19 November 2017

The success of *Blood Swept Lands and Seas of Red* at the Tower of London in 2014 revealed a very real desire to continue to remember the dead of the First World War. Yet it is likely few of those visitors were aware that just across the road is a Commonwealth War Graves Commission (CWGC) memorial commemorating those members of the Merchant Navy who have no known grave – just one of 13,000 locations in the UK where the CWGC commemorates the war dead.

Hosting Poppies: *Wave* at one of these memorials, bearing the names of those who died at sea, was a fitting tribute and an imaginative means of engaging people of all ages with our work, with this commemorative legacy on their doorstep, and with the often overlooked sacrifice of the men and women who served and died at sea.

It also felt right that we take *Wave* further afield – to the CWGC Plymouth Naval Memorial – to reach audiences that might not otherwise have the opportunity to see the iconic sculpture. The enthusiastic and supportive response we received from the city and its people convinced us this was the right choice.

The memorial may be a functional item – in that it commemorates the 7,200 naval personnel of the First World War and 16,000 of the Second World War who were lost or buried at sea – but it is also a work of art in its own right. Designed by Sir Robert Lorimer, with sculpture by Henry Poole, today its importance is acknowledged in its Grade I listing.

To protect the memorial an artificial base, made of wood but painted to look like stone, for the ceramic poppies to stand on was created ahead of the sculpture's installation. This feature certainly had people talking – many visitors were convinced we had drilled into the precious stonework before our volunteers set their minds at rest.

Unusually, for an organisation that mows the equivalent of 1,000 football pitches every week, we also let the grass within the memorial grow up around the sculpture for the duration of their presentation, to create the impression they were emerging from their natural landscape.

The site was perhaps more 'open' than many of the other host venues. Plymouth Hoe is a busy space – hosting events as varied as university graduations to Bonfire Night celebrations – and this had to be factored in. But it also ensured we attracted many visitors who would otherwise not have engaged with a work of art or a war memorial.

No matter who they were or where they came from, every visitor was made to feel welcome by one of our amazing volunteers. More than 200 were recruited, trained and equipped. The vast majority are still volunteering – creating a network and legacy in the region that will reap benefits for CWGC for years to come.

But the success of the project was in the reaction and response of those visitors who came in such huge numbers – many of them returning time and again to witness the weekly staging of the 'Last Post' each Saturday night. It was our hope people would visit, read the names on the memorial's walls and remember the sacrifice they made. They did and they are still coming.

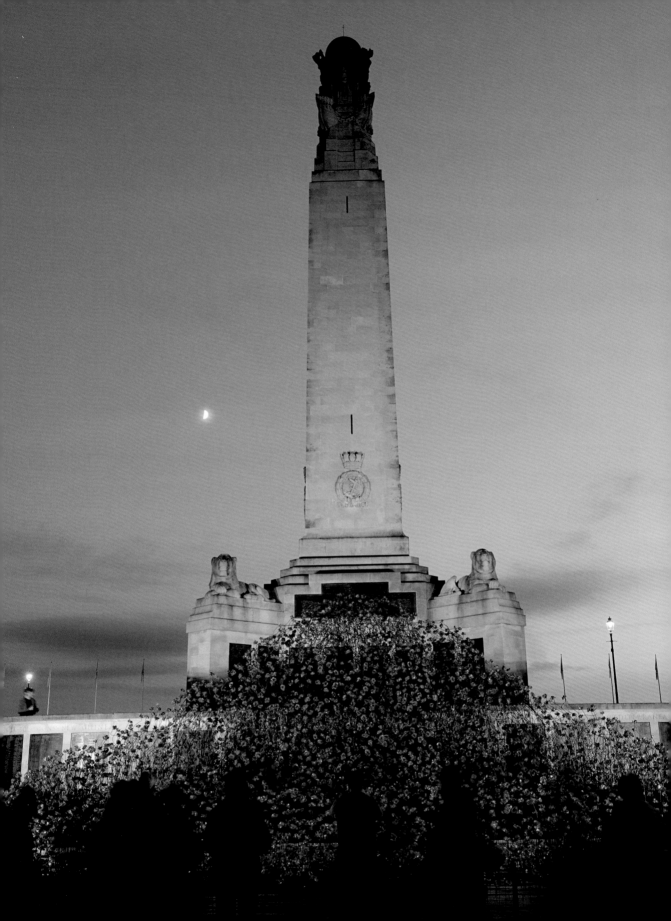

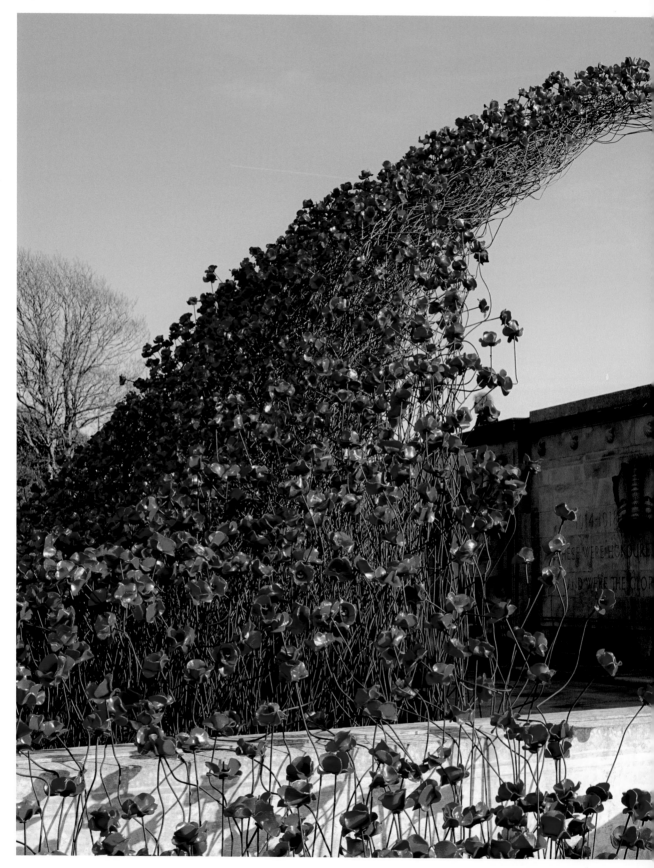

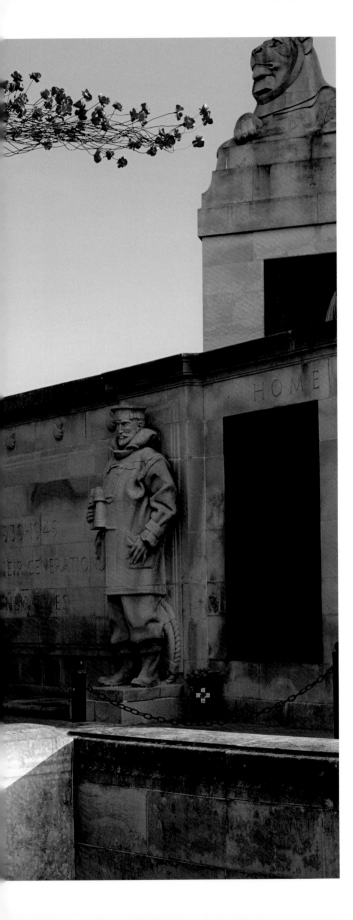

'It is bringing the past into the future, which is what we've got to do, and keep remembering.'

Visitor

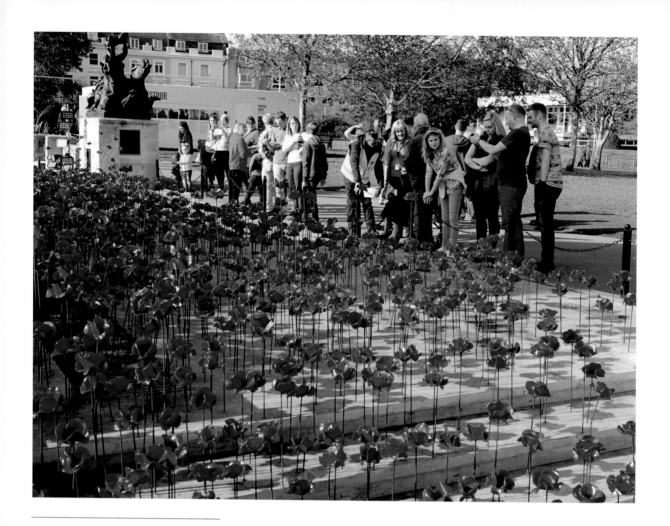

'*Wave* fits the memorial
perfectly. It's almost as
if they were made for
each other.'

Volunteer

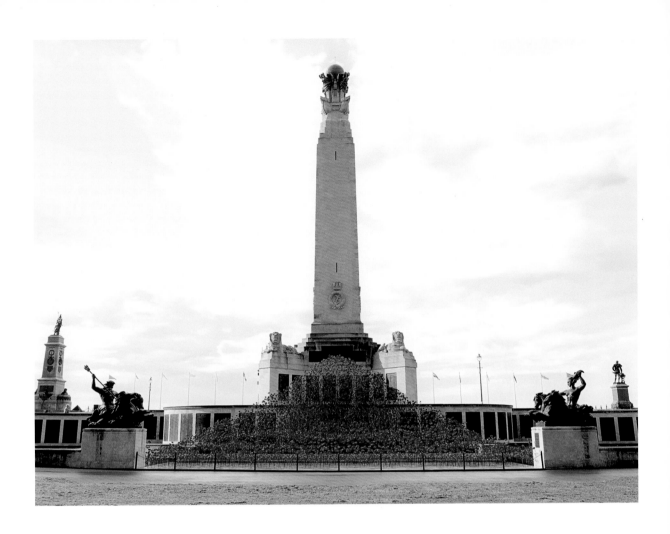

Ulster Museum Belfast

National Museums Northern Ireland and Belfast International Arts Festival joined together to bring *Weeping Window* to Belfast for the people of Northern Ireland, and across the island of Ireland, to experience this unique, powerful and deeply moving sculpture.

The poppy is a contested symbol within Northern Ireland. From the outset we were mindful that what was required was an inclusive approach to this divisive symbol represented in the sculpture. And so commenced a year of intensive planning and development. We engaged, listened to and considered a broad range of interests and experiences from stakeholders and communities, in particular those where there is a history of deprivation and community tension.

While the sculpture was in Belfast an extensive public programme entitled 'Participate in Poppies' took place at the Ulster Museum, including a series of talks, workshops, performances, tours and film screenings. As part of this varied programme, connections to the sculpture and the relevance of symbolism were explored through National Museums NI's wider collections. A number of these special events were delivered during Belfast International Arts Festival, through their 'Contested Legacies' programme.

The Ulster Museum is one of the most iconic buildings in Belfast and houses Northern Ireland's national collections of art, history and natural science. In 2014, to mark the centenary of the outbreak of the First World War, the Museum opened a new, permanent 'Modern History' gallery.

Belfast International Arts Festival is Northern Ireland's leading annual celebration of contemporary arts from home and abroad.

Memory and history, and how they influence our appreciation and understanding of freedom, were themes that underpinned the 2017 edition of the Festival. *Weeping Window* not only sat appropriately within these themes but also within the wider public discourse the Festival has been pursuing with its audiences in recent years, reflecting on the many and varied legacies of the First World War.

A large volunteer team – the Poppies Ambassadors – were recruited to help deliver a world-class visitor experience to everyone who visited the artwork during its time in Belfast. Were we successful? The poppies were certainly popular, with an overwhelming 128,960 people visiting them in the 52 days they were in Belfast – an increase of 84% on visitors to the Ulster Museum for the period in the previous year.

We did, as expected, face some challenges and voices of dissent expressed through some visitor feedback, but these were less than 1% of all those received, so were drowned out by the positive voices. This was also reflected through our social media platforms.

At the start of the process we discussed how, through displaying *Weeping Window* and delivering our accompanying public programme, we would be 'taking the pulse of Northern Ireland', seeing how healthy it is and how ready to accept and maturely address something that could once have provoked discord and bitter recriminations. Our experience suggests a strong and encouraging pulse, a sign of a healthy post-conflict society with an appetite for public history and all its opportunities for reflecting, learning, sharing and understanding.

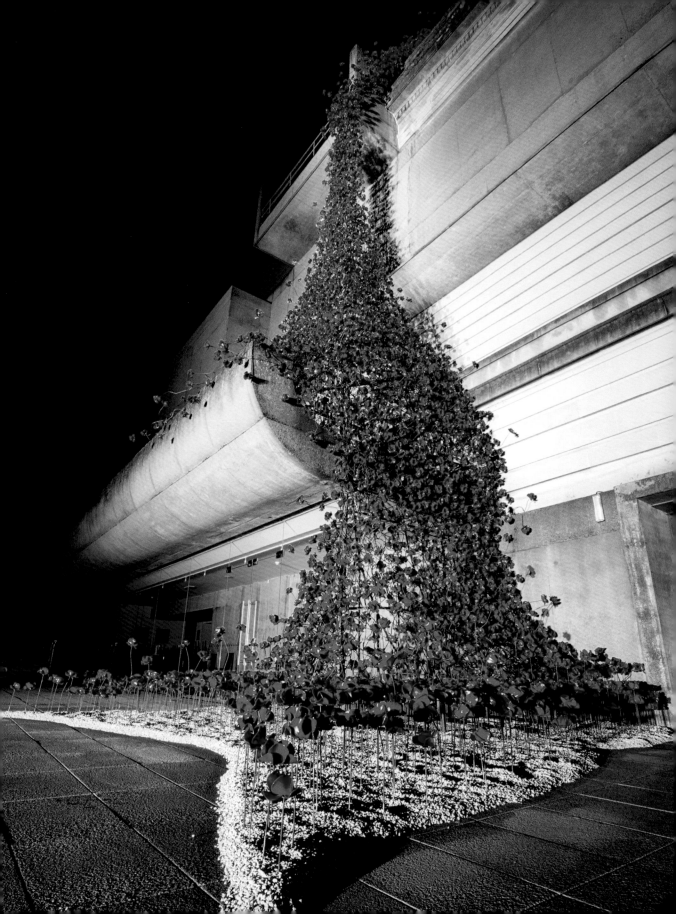

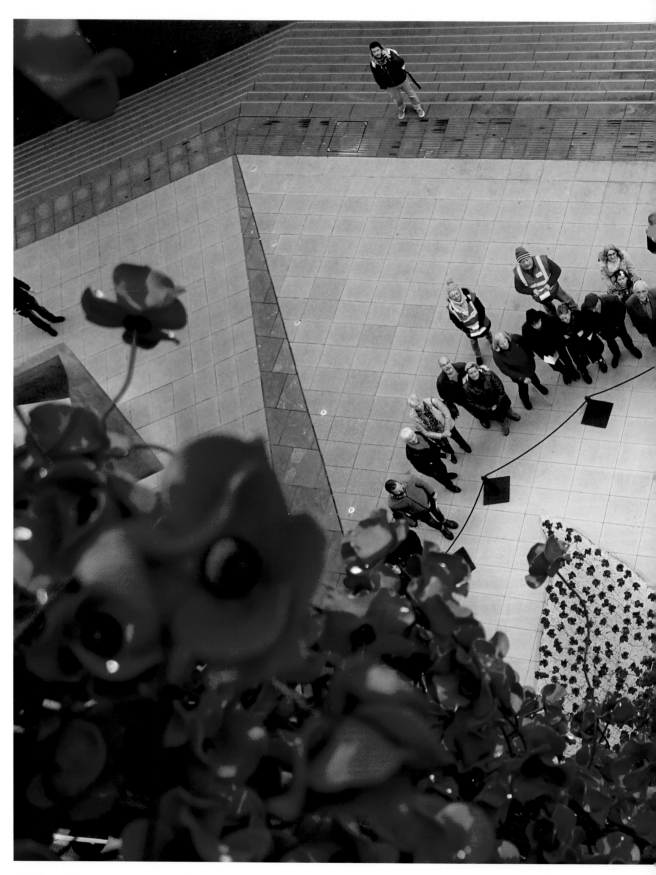

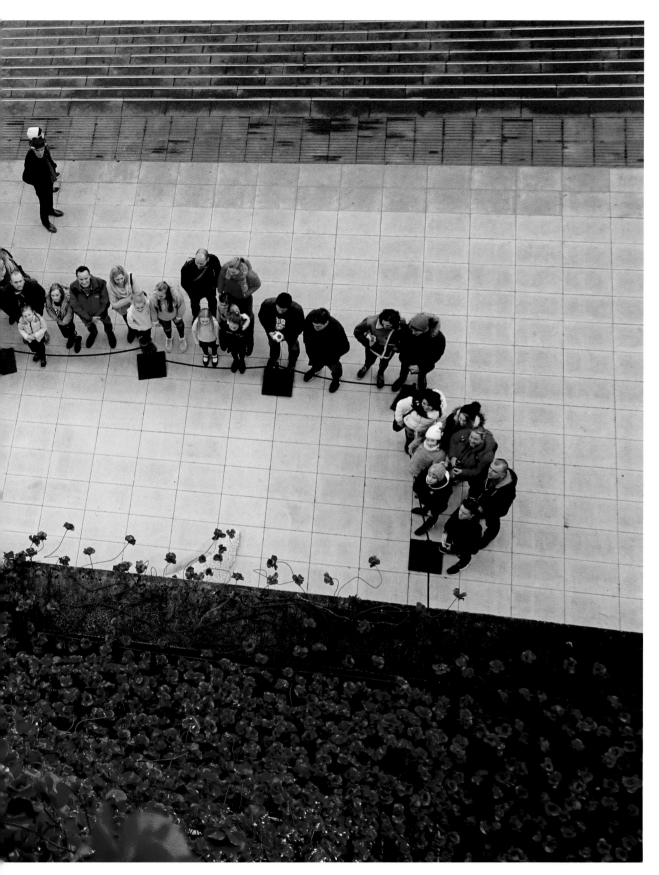

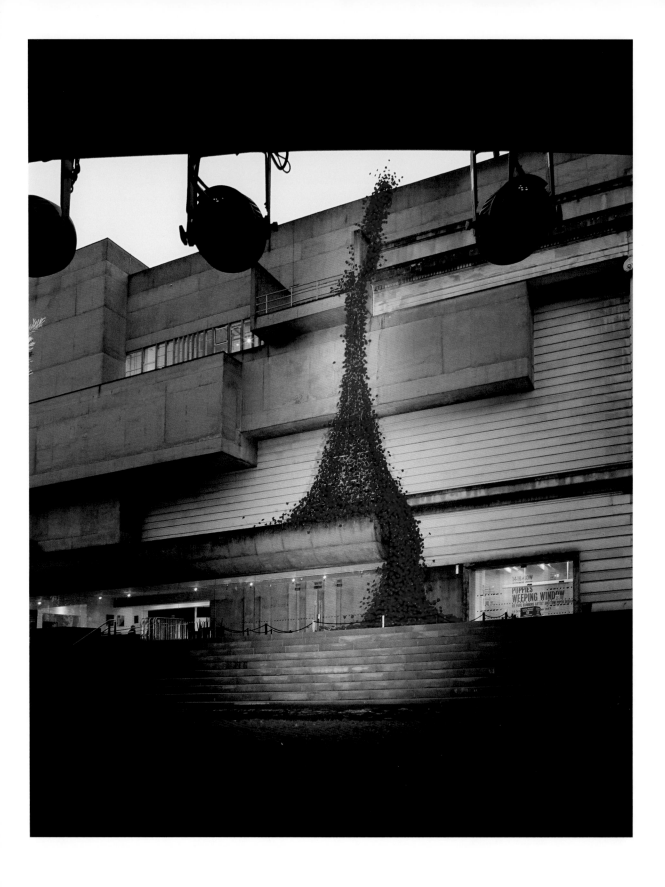

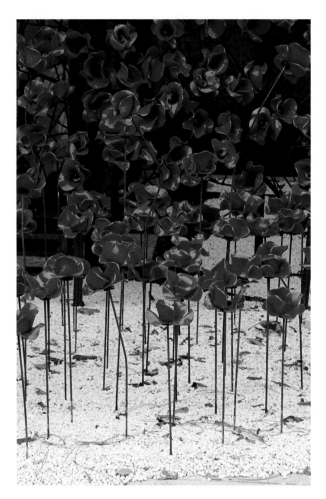

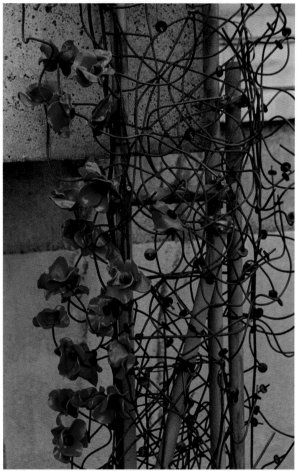

'An excellent idea.
Hoping it bridges the gap
between the two divided
communities, as both
were involved.'

Visitor

2018

Hereford Cathedral
Royal Armouries Fort Nelson
Carlisle Castle
Middleport Pottery Stoke-on-Trent

Hereford Cathedral

14 March—29 April 2018

It was a privilege to be part of the team that brought *Weeping Window* to Hereford Cathedral and to be involved with a project that had such a public impact.

The installation process of *Weeping Window* was hampered by snow and freezing conditions, but was supported by an enthusiastic team of local art handlers whose progress was watched and admired by thousands of passers-by. More than 250 people of all ages volunteered their time and skills to support the project. The feedback from our volunteers was hugely positive and moving.

The men and women of Herefordshire made a huge contribution to the war effort during the First World War. Young men were recruited into the Herefordshire Regiment, which expanded to three battalions during this time, landing in Suvla Bay in Gallipoli in August 1915 before being transferred to the Western Front in 1918. Shells were produced at the Rotherwas Munitions Factory from November 1916, which saw an influx of thousands of women munition workers into the County.

Hereford Cathedral dates from 1120 and is the home of the Mappa Mundi, a medieval map of the known world dating from c.1300, one of only four 1217 Magna Carta in existence and the world's largest Chained Library. First World War memorials in the cathedral include a plaque commemorating men of all ranks of the Herefordshire Regiment who died on campaigns in Egypt, Gallipoli, Palestine and France, and one

to four former cathedral choristers, along with students and staff from the cathedral school. A Book of Remembrance for the husbands and sons of members of the Hereford Mothers' Union who gave their lives in the war is on permanent display.

In September 2018, Hereford Cathedral unveiled a new plaque honouring soldier Allan Leonard Lewis, the only Herefordshire-born recipient of the Victoria Cross. Lewis was killed in September 1918, aged 23. The Victoria Cross was presented to his parents by H.M. King George V at Buckingham Palace in April 1919.

In collaboration with Herefordshire Council, Hereford Cathedral ran a programme of events and learning opportunities focused on Herefordshire and the Home Front, which included exhibitions at venues across the city. A large number of local schools visited the poppies and participated in our schools learning programme. Unveiled during the presentation of the sculpture was a plaque dedicated to the memory of six children who lost their lives during a fire at a regimental fundraising concert in 1916. The final day *Weeping Window* was open to the public, a service was held commemorating the 100th anniversary of the founding of the RAF.

The lasting legacy will be one of enhanced community cohesion, understanding of Herefordshire's contribution to the First World War and the importance and power of volunteering.

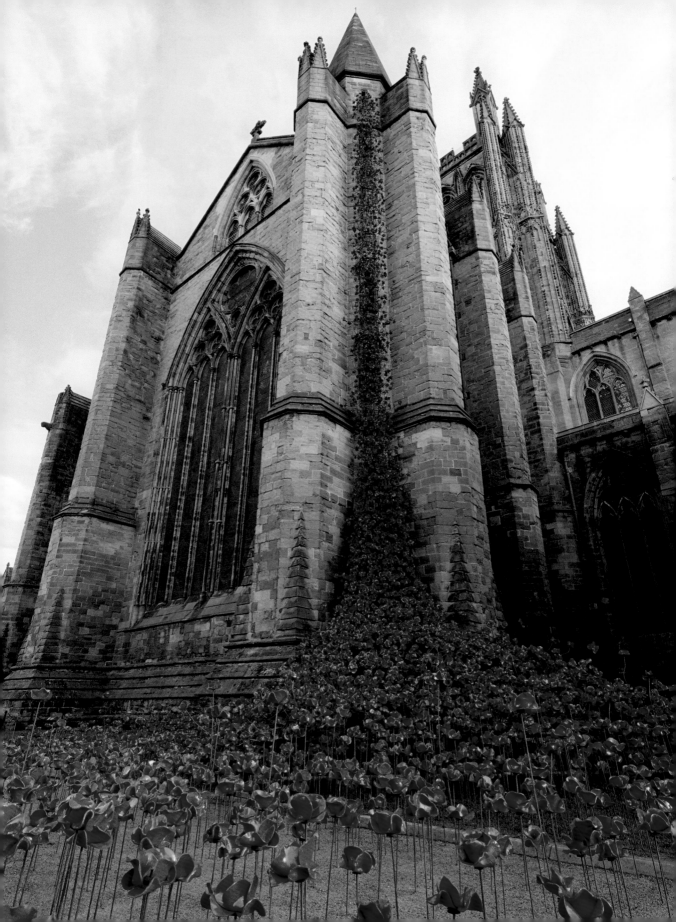

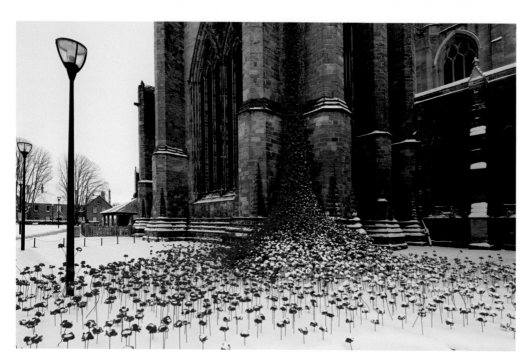

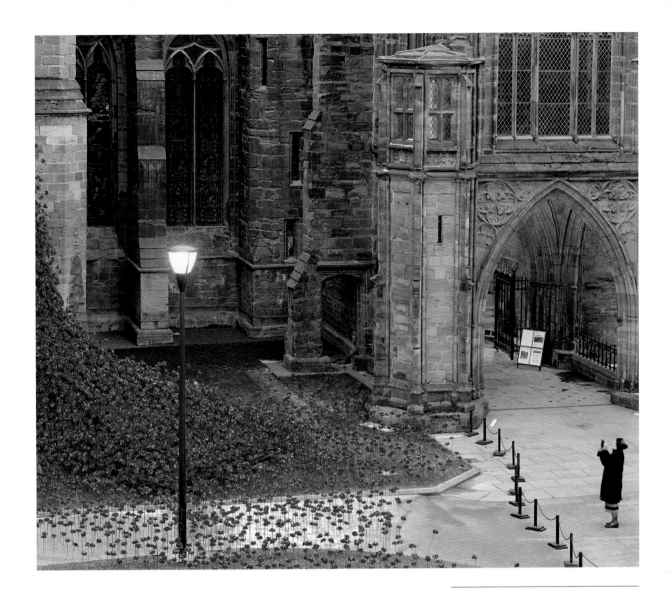

'It was an honour to listen to the accounts from some visitors about their relatives who fought in the First World War and what the *Weeping Window* means to them.'

Volunteer

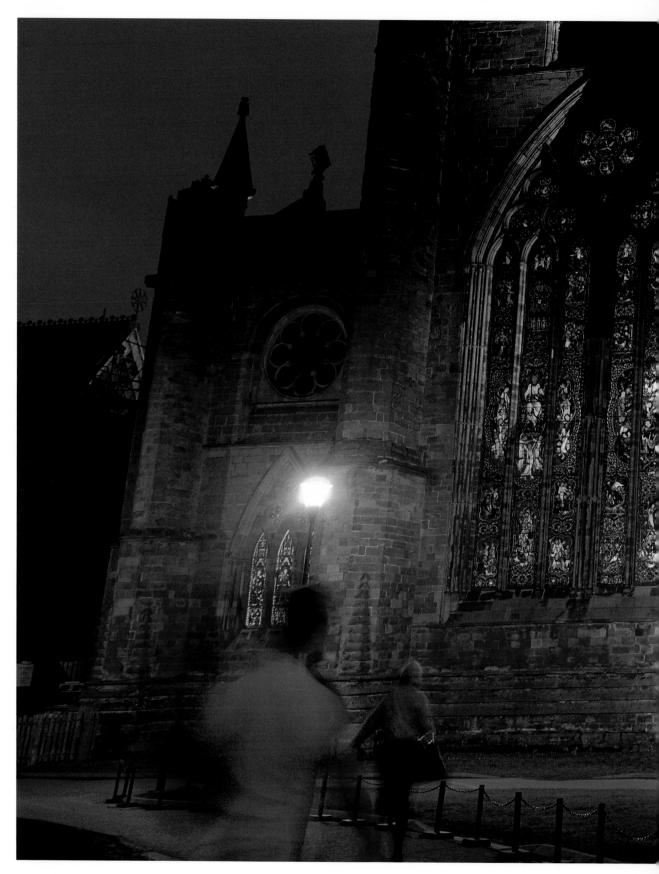

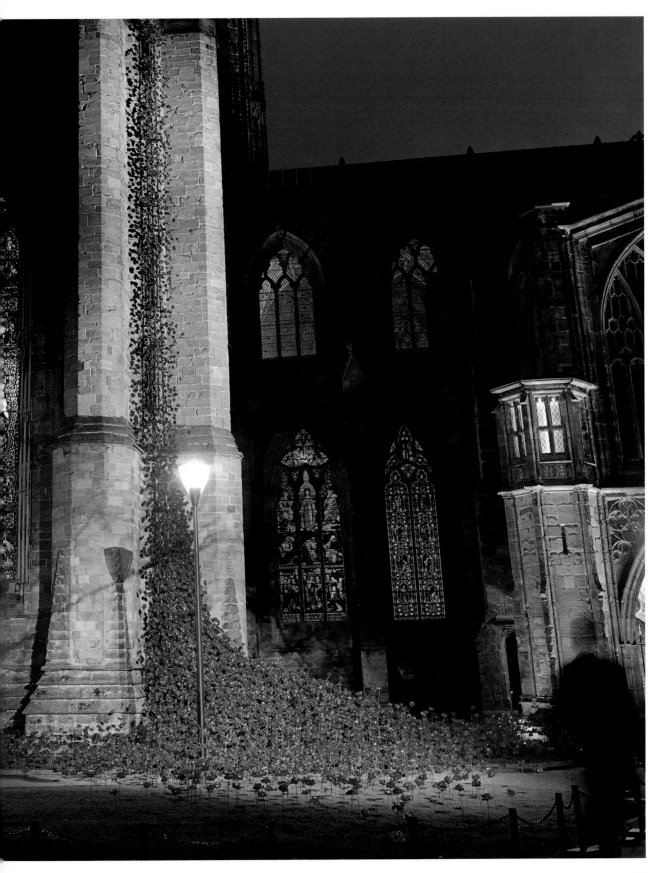

Royal Armouries Fort Nelson

13 April–24 June 2018

Royal Armouries Fort Nelson provided a wonderful setting for the iconic Poppies: *Wave* during the spring of 2018. The sculpture rose above the ramparts of this nineteenth-century Palmerston Fort, which looks out towards the Solent on one side and across the rolling countryside of Hampshire on the other.

The Fort is one of five built on Portsdown Hill in the 1860s as part of a large ring of defences to protect the naval base of Portsmouth. In 1914, Fort Nelson was a training base where Royal Garrison Artillery troops were trained to use 60-pounder breech-loading guns. When the First World War broke out these troops were sent to France, where artillery would become a key weapon in the conflict. The fort itself became a transit base of soldiers, including Kitchener's Army, on their way to the Western Front. Fort Nelson now displays artillery pieces from Royal Armouries' national collection of arms and armour.

The architecture and layout of the fort provided challenges for finalising the location of the sculpture and special walkways were built to access the ramparts to enable visitors to get close to the artwork. Installation took place during a bitterly cold and snowy spell of weather in early spring. As a museum the site welcomes many visitors but it needed to increase car parking and facilities to cope with the large influx of visitors. Hampshire County Council provided invaluable planning support throughout. The effort was worth it as visitors were able to enjoy a full view of *Wave* from the fort's parade ground as well as being able to walk underneath the top of the sculpture.

One hundred and fifteen passionate and fantastic volunteers were recruited. The positive feedback from visitors commenting on the warm welcome they received from staff and volunteers was one of the many highlights. The volunteers provided over 6,500 hours of their personal time and many have become a close-knit group of friends who are keen to offer more of their time in the future.

Whole families, often encompassing three generations, visited together to reflect in the presence of *Wave*. In addition, almost 3,000 children came with their schools and many participated in a special programme of education sessions. Families used the trails enthusiastically with many leaving thoughtful and moving reflections on memory cards. We closed on the final day with the 'Last Post' performed by a single bugler.

Hosting *Wave* has been a remarkable experience and has provided a lasting legacy for Fort Nelson. Many visitors had never been before and were able to discover how much there was to do and see in the museum galleries, the tunnels, and other spaces, as well as enjoying the stunning views. To witness the impact of Poppies: *Wave* on so many people, the way in which it connected them to their own family stories and to the many who lost their lives has been a deep privilege.

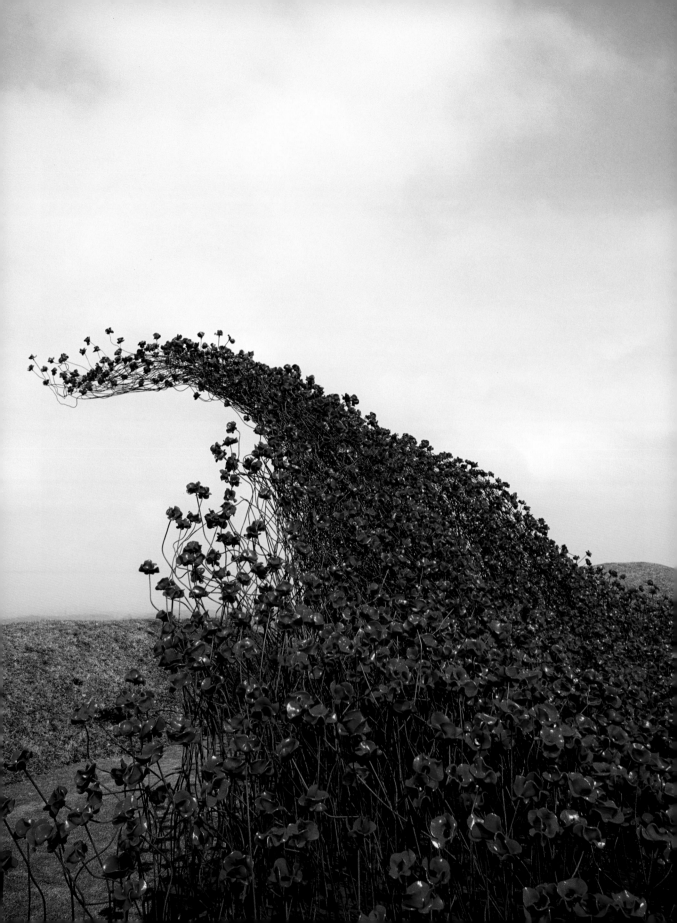

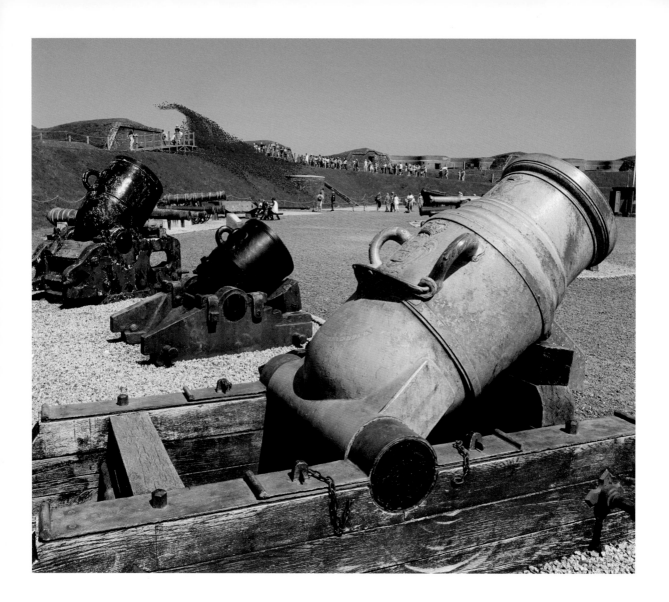

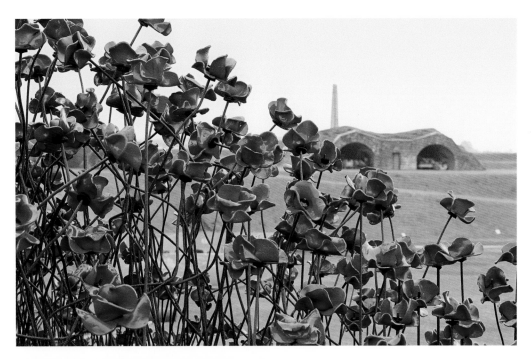

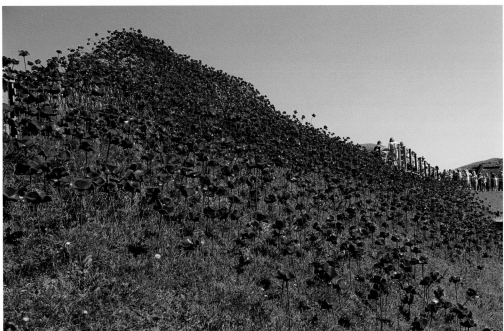

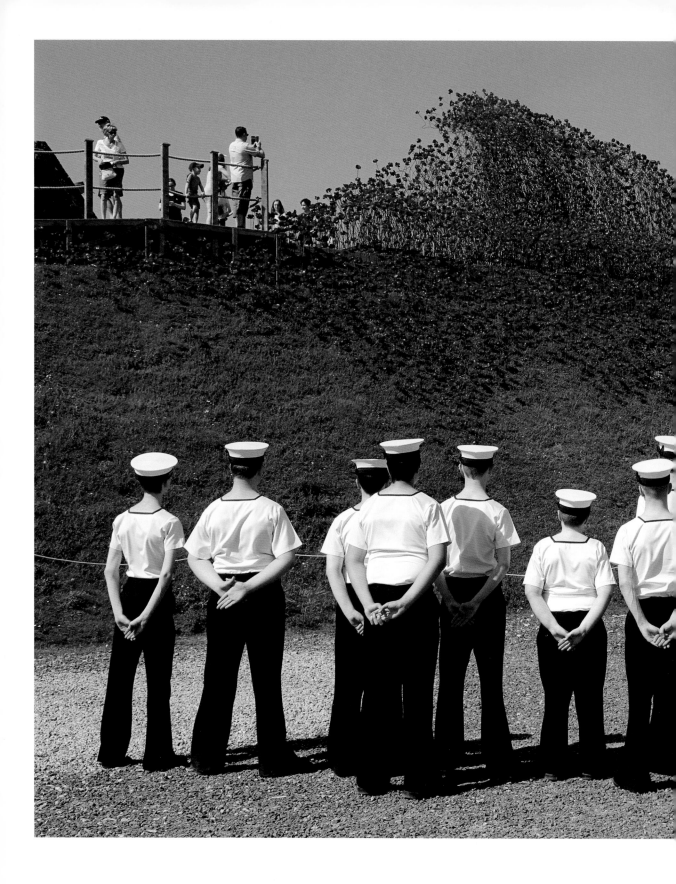

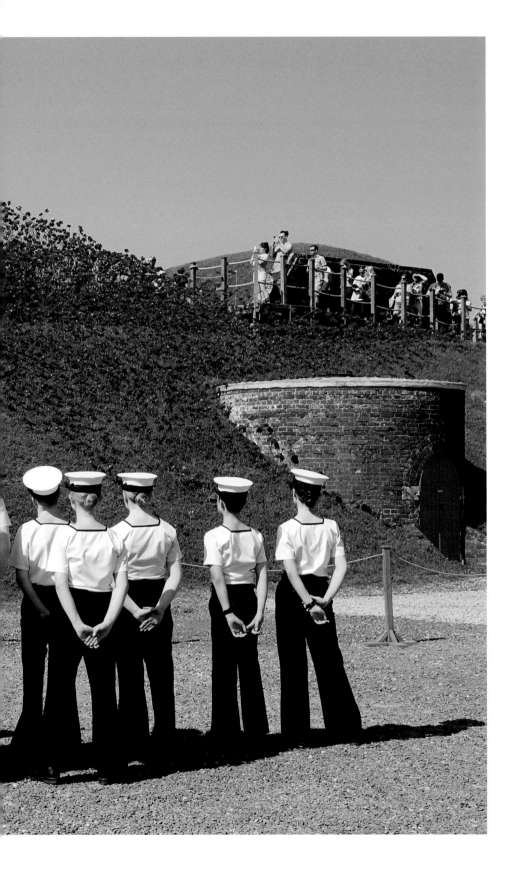

Carlisle Castle

23 May–8 July 2018

For over 900 years, Carlisle Castle has served as a flashpoint of frontier warfare between Scotland and England, a stronghold integral in skirmishes, sieges and uprisings, and is revered as a notorious prison, including holding Mary Queen of Scots in 1568. Unlike many castles, it remained operational well into the twentieth century and it is this military legacy that afforded us the privilege of presenting the extraordinary *Weeping Window* sculpture for 47 days in May, June and July 2018.

The sculpture was displayed from the top of the keep, arching over the inner ward wall and cascading down into the outer ward of the castle complex, an area which incorporates the military barracks and parade ground where troops were housed and trained in preparation for front line combat. The flowing structure somehow seemed to bring an element of grace and ethereal beauty to this leviathan of a building, something that was not lost on the visitors. With the arch of the sculpture viewed from beneath, the delicacy of the poppies seemed to take people by surprise.

Installed in just over a week, the team enjoyed exceptionally good weather throughout the process, remarking on their good fortune knowing what the north west of England can often deliver without knowledge that the next six and a half weeks would see some of the highest temperatures to hit Britain since the heat wave of 1976. Many of the 140,000 visitors commented that they had been grateful for the cool of the dungeons and had found respite from the heat within the castle's walls, something the 100 volunteers also appreciated.

During the First World War, Carlisle Castle provided the headquarters for the Volunteer Training Corps, accommodation for the Labour Corps and from 1873 to 1959 the castle was the headquarters for the King's Own Royal Border Regiment. A total of 23,000 recruits passed through the castle, with the war costing the Border Regiment nearly 7,000 lives. The Regiment saw action in almost every theatre of war: France, Flanders, India, Burma and Gallipoli, Italy, Mesopotamia and Macedonia. Many honours were awarded to the Regiment, including five Victoria Crosses. The fact that so many soldiers from the region had not returned home resonated with visitors, and many found the vast number of poppies woven into the sculpture a salutary reminder of the young men who had died.

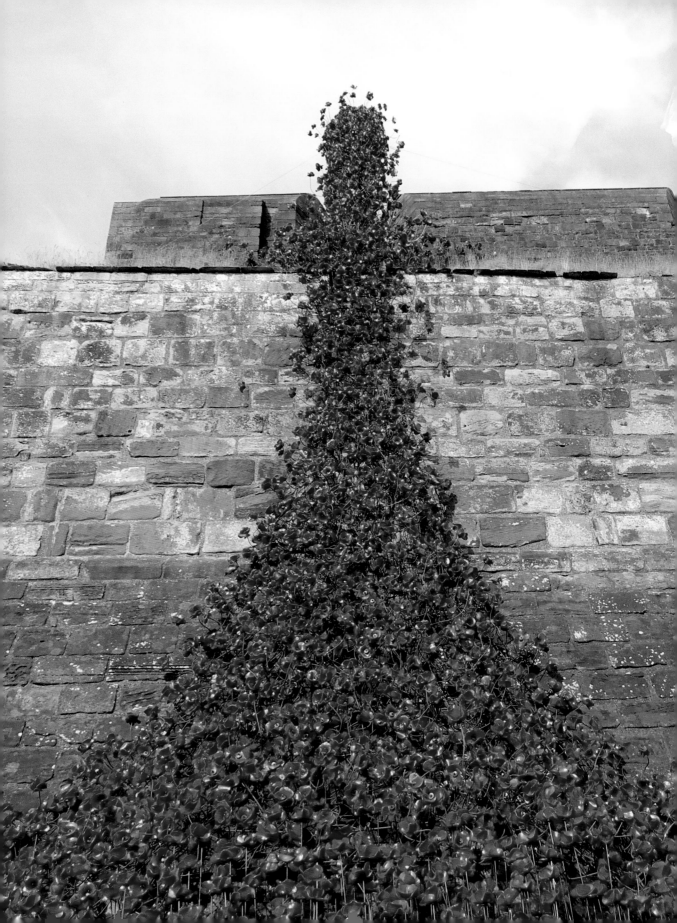

'There is no fairytale element to Carlisle Castle ... *Weeping Window* in appearance is the antithesis of all that Carlisle beholds but the ethos feels absolutely right ... The sculpture is a seemly honour for those who served and lost their lives in the First World War, and reminded us of sacrifice in any war.'

John Bonner,
Site Manager of Carlisle Castle

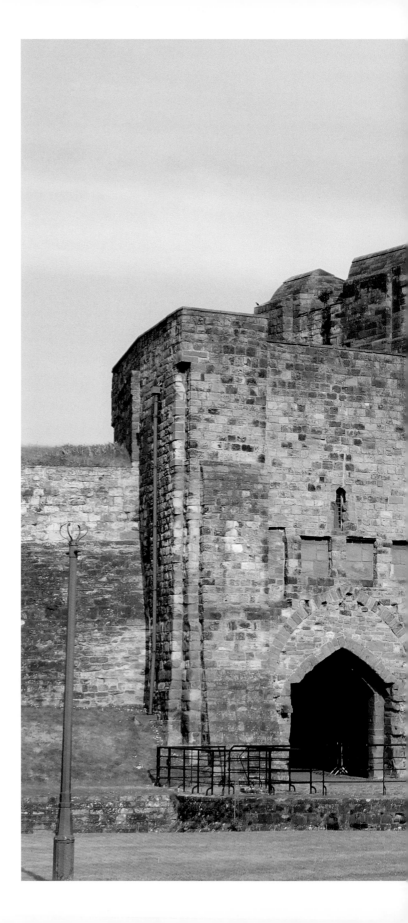

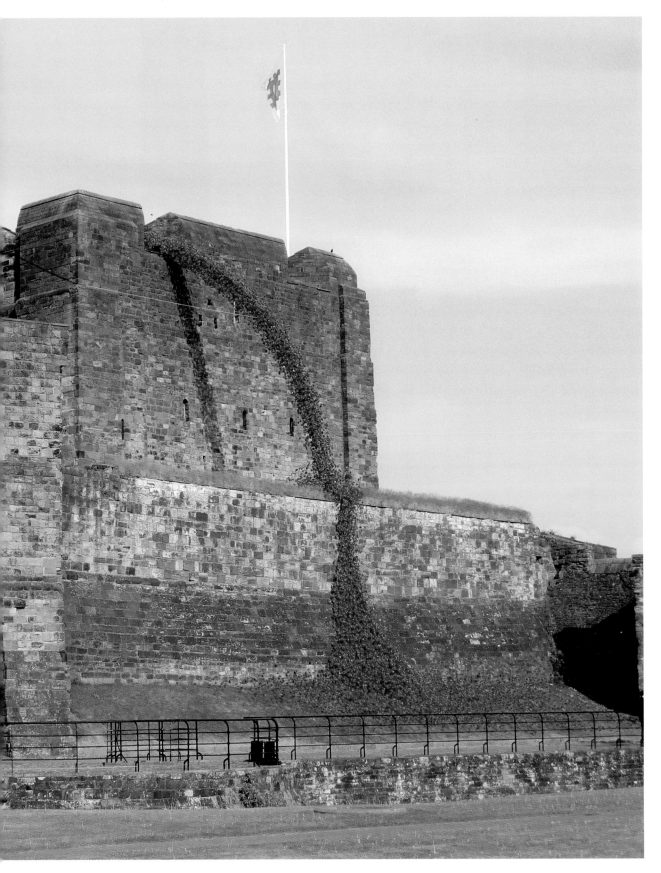

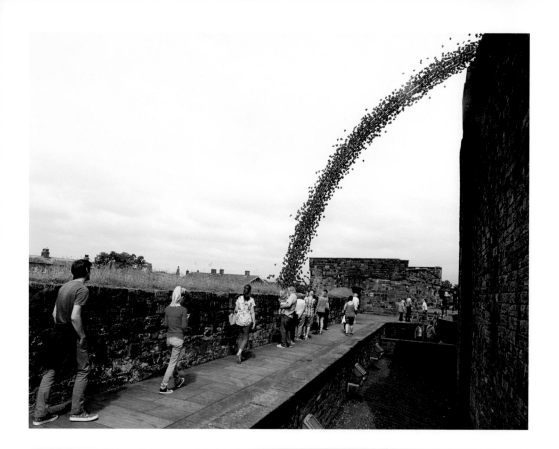

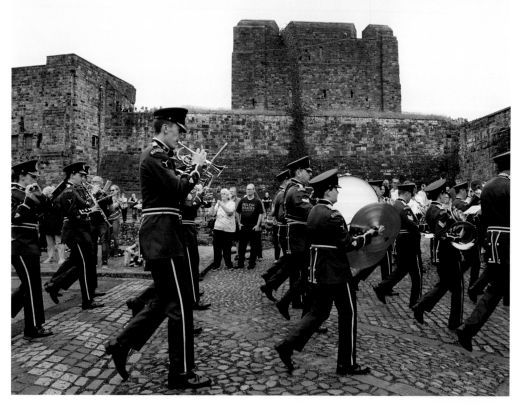

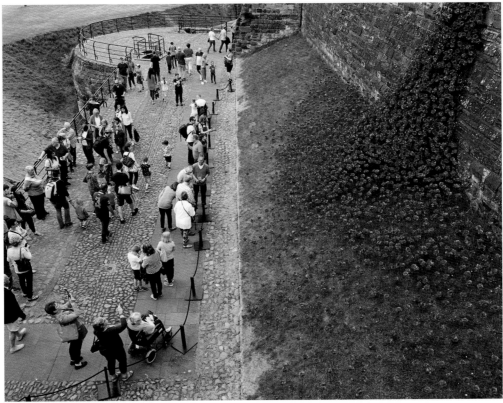

Middleport Pottery Stoke-on-Trent

2 August–16 September 2018

Stoke-on-Trent is officially recognised as the World Capital of Ceramics, and Middleport Pottery has been operating since 1889. When it first opened, the state of the art building was designed to make the production process more efficient and improve conditions for the workforce. It is now designated as a grade II listed building, as is its bottle oven – one of only 48 left in the Potteries. Middleport Pottery opened as a visitor attraction in 2014.

During the First World War, demand for the ceramic goods made in the area greatly increased. These included tableware for hospitals, homes and the military; propaganda-ware, including small ceramic tanks and battleships; plates with patriotic designs or messages on them; and ceramics to mark both the early stages of the war and the Armistice at the end.

The First World War also saw women take on bigger roles in the pottery industry; with the men volunteering or being called-up, they came to the fore as decorators and designers, taking key roles from men and being recognised after the war as leading lights.

Stoke-on-Trent was integral to the original installation, *Blood Swept Lands and Seas of Red*, as a base for the creation of just under half of the total number of ceramic poppies produced. Stoke-on-Trent also provided the clay used in the creation of all the poppies. Middleport Pottery is the final regional destination for the Poppies: *Weeping Window* sculpture before it is presented at IWM London and then becomes part of the permanent collections at Imperial War Museums.

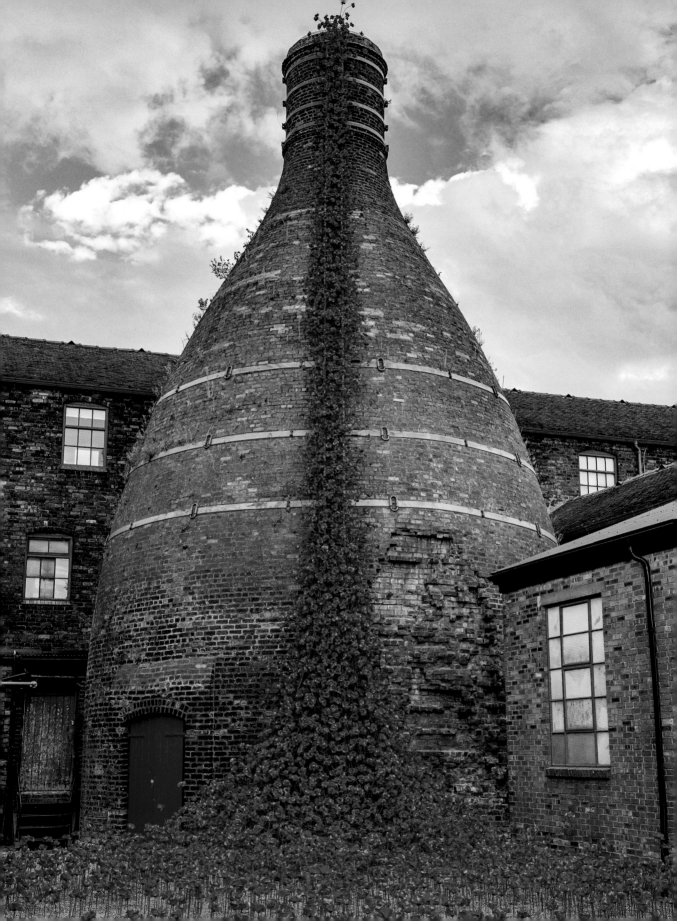

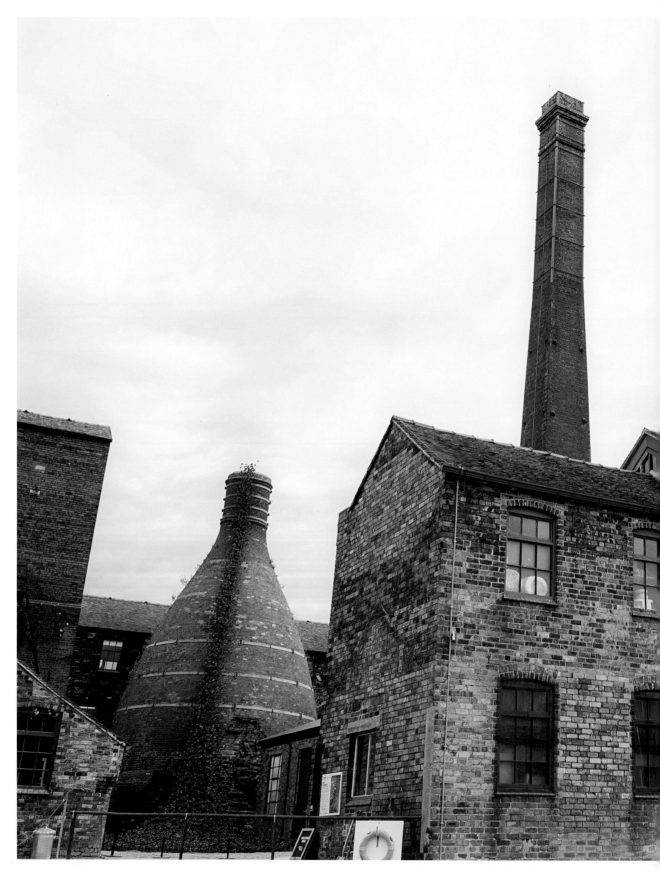

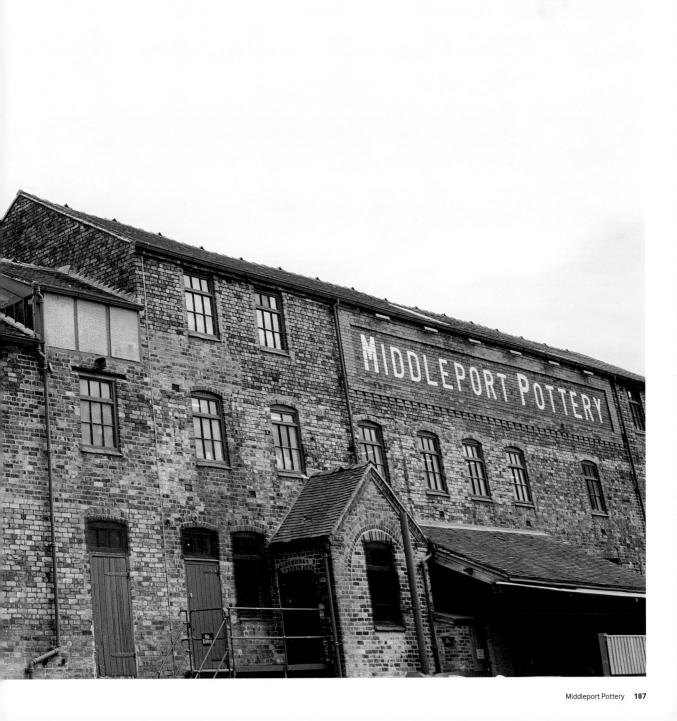

'Poppies: *Weeping Window*
represents one of the
most significant cultural
artworks in the UK
and we are absolutely
delighted for the
sculpture to be here in
Stoke-on-Trent.'

Abi Brown, Deputy Leader
of Stoke-on-Trent City Council

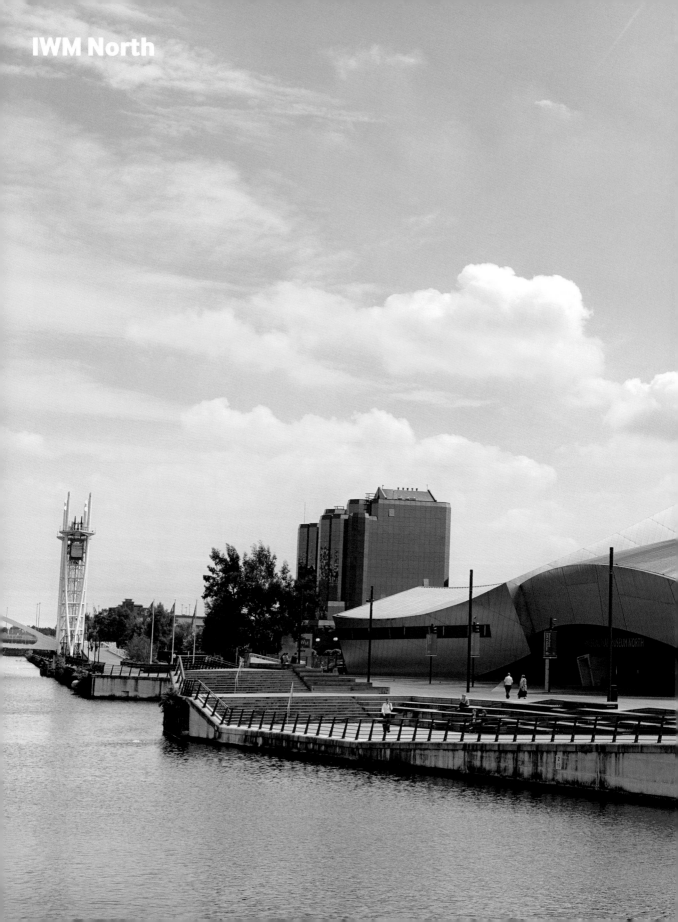

IWM North

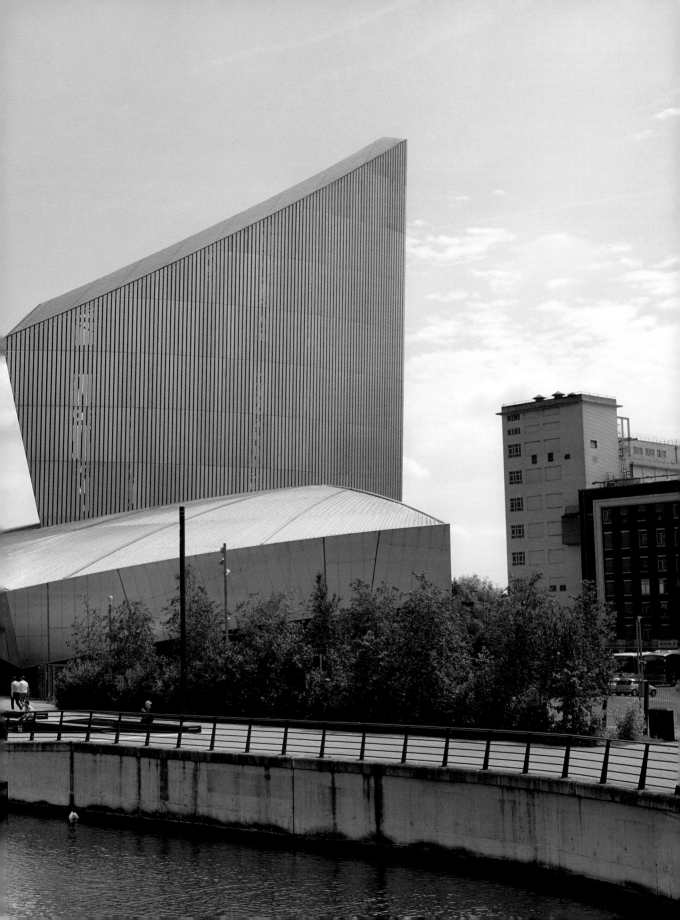

IWM London

Where Are
The Poppies
Now

Where Are The Poppies Now

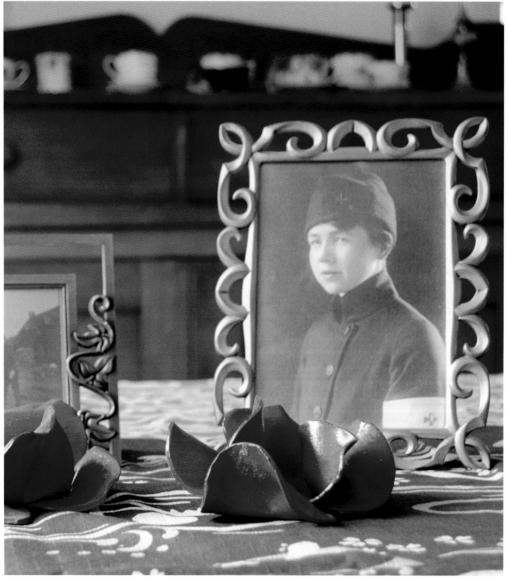

USA

Canada

France

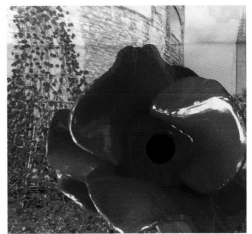

Japan

Cyprus

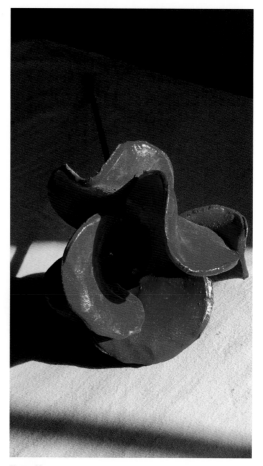

Tenerife

New Zealand

Hong Kong

South Africa

The United Kingdom

United Arab Emirates

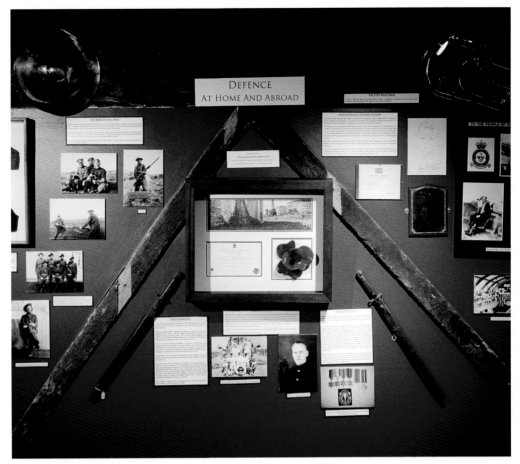

The Falkland Islands

The Cayman Islands

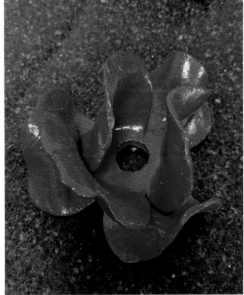

Australia

Acknowledgements

This book would not have been possible without the hard work and cooperation of so many people and organisations. Thanks go to:

Those from each tour venue who contributed text: Nina Rogers and Yorkshire Sculpture Park; Elizabeth Ritson, Rowan Brown, Jemma Swinney, Deborah Tate and Woodhorn Museum; Jen Falding and Culture Liverpool; Antony Mottershead, Karen Greaves and Orkney Islands Council; Jon Hogan and Lincolnshire County Council; Anne Kinnes and The Black Watch Castle and Museum; Ffion Reynolds and Cadw; Martin Taylor, Malcolm Dunn, Jonathan Barker, Hull Culture and Leisure and Hull City Council; Simon May, Kirsty Horseman, Sharon Wheeler and Southend-on-Sea Borough Council; Louise Wilks, Matthew Frost and Derby City Council; Alice Randone, Sian Pitman and Cynulliad Cenedlaethol Cymru; Liz Woodfield and the Commonwealth War Graves Commission; Sinead Cunningham, Belfast International Arts Festival and National Museums Northern Ireland; Hannah McSherry, Glyn Morgan, Hereford Cathedral and Herefordshire Council; Siona Mackelworth and the team at Royal Armouries, Fort Nelson; Kate McMullen and English Heritage.

Those who shared where their poppies are now: Ahmed, Andrea, Andrea, Andrew, Bridget, Charlotte, Jane, Katherine, Michael, Natalie, Oliver, Paul, Peter, Petra, Robyn, Ruth and Wendy.

Dan Wolfe and Historic Royal Palaces. Vikki Heywood, Jenny Waldman, Nigel Hinds, Claire Eva, Linda Bernhardt, Alice Boff, Emma Dunton and all at 14-18 NOW. Janice White, Kathryn Winter, Rebecca Woodham and everyone at The Cogency. All at HTMD. The Space. Ocky Murray. Nick Finegold and Zebra. Andrew Tunnard and the photography team at IWM.

Paul Cummins and Tom Piper.

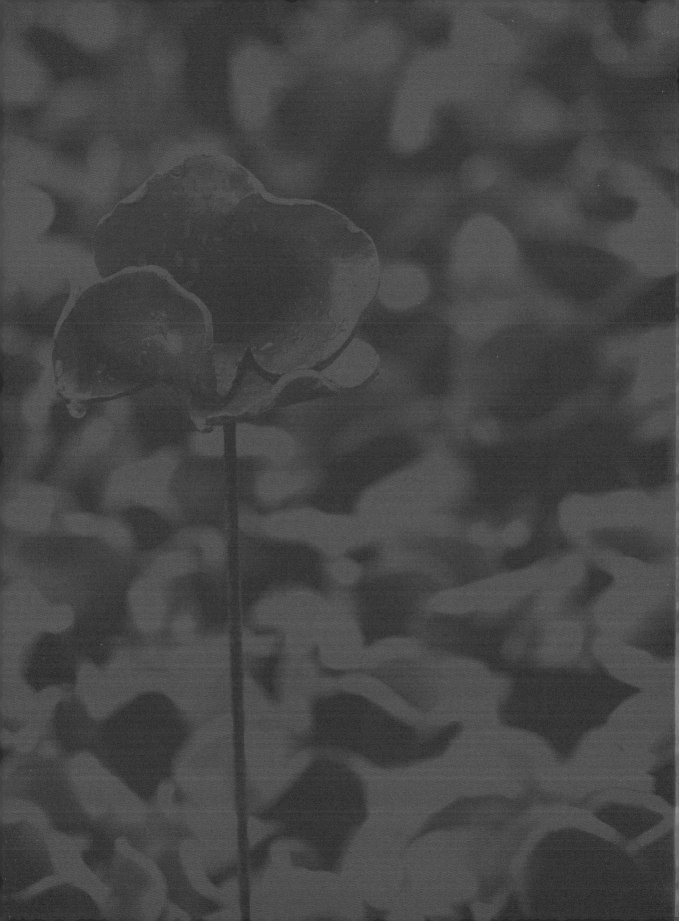

Picture credits

All images © IWM unless otherwise stated. Every effort has been made to contact all copyright holders. The publishers will be glad to make good in future editions any error or omissions brought to their attention.

The Tower of London

Dan Kitwood / Getty Images: p.21
PA Archive / PA Images: pp 22–23, pp 28–29, p.31, p.56, pp 66–67, pp 72–73
Ron Ellis / Shutterstock.com: p.24, p.25, p.68
astudio / Shutterstock.com: p.24
Lorna Roberts / Shutterstock.com: p.25
chrisdorney / Shutterstock.com: p.25
Gogiphoto / Shutterstock.com: p.25
BBA Photography / Shutterstock.com: p.27
Oosoom / Alamy Stock Photo: p.32
Nils Jorgensen/REX/Shutterstock: p.33
Paul Brown / Alamy Stock Photo: p.34, p.35
© leahairphotography: pp 36–37
Guy Corbishley / Alamy Stock Photo: p.40
BigRoloImages / Shutterstock.com: pp 46–47
James D. Morgan/REX/Shutterstock: p.49
John McLellan/REX/Shutterstock: pp 50–51
Geoff Shaw / Alamy Stock Photo: pp 52–53
Carolyn Jenkins / Alamy Stock Photo: p.53
Max Mumby/Indigo / Getty Images: pp 54–55
Nick Harvey/REX/Shutterstock: pp 58–59
Sebastian Remme/REX/Shutterstock: pp 60–61
Kev Gregory / Shutterstock.com: p.62, p.71
Amer Ghazzal/REX/Shutterstock: p.62
Peter Macdiarmid / Getty Images: p.69
Alan Davidson/Silverhub/REX/Shutterstock: p.70
Ian Ward / Alamy Stock Photo: p.72
Karwai Tang / Getty Images: pp 74–75

The Tour

Liverpool City Council / Mark McNulty: pp 80–81, p.95, p.98
'Poppies:Wave' by Bryan Ledgard (https://creativecommons.org/licenses/by/2.0/): p.83
Nigel Roddis / Getty Images: pp 84–85, p.86
Tom Piper: p.86, p.106, p.119, p.133, p.151
© 2015 — Jonathan Pow: p.87
Colin Davison Photography (www.rosellastudios.com): p.89, p.90, p.91, pp 92–93
Liverpool City Council / Ant Clausen: pp 96–97, p.98, p.99
Ellie Kurttz: pp 100–101, p.103, pp 104–105, p.107, p.113, p.115, p.116, p.117, p.150, p.151, p.163
Michael Bowles / Getty Images: p.107
© Gideon Mendel: p.109, pp 126–127, p.129, pp 130–131, p.133, p.135, p.136, p.137, p.138, p.142, p.145, p.147, pp 148–149, p.153, pp 154–155, p.156, pp 160–161, p.162, pp 164–165, p.167, p.168, p.169, pp 170–171, p173, p.174, p.175, pp 176–177, p.182, p.183
'Poppies at Lincoln Castle' by Paul Hudson (https://creativecommons.org/licenses/by/2.0/): p.110
Angelina Dimitrova / Shutterstock.com: p.111
© Stuart Wilde Photography Ltd: p.112, p.113
Corporal Trevor Macey—Lillie, Black Watch Castle and Museum: pp 118–119
SIMON STAPLEY / Alamy Stock Photo: p.121
Fotan / Alamy Stock Photo: pp 122–123
© Ffion Reynolds: pp 124–125
Ian Francis stock / Alamy Stock Photo: p.132
Harvey Wood / Alamy Stock Photo: p.141
'Poppies at the Silk Mill' by Dun.can (https://creativecommons.org/licenses/by/2.0/): p.143
Richard Holmes / Alamy Stock Photo: pp 144–145
Matt Keeble / Getty Images: p.157
© Press Eye/Darren Kidd: p.159
Richard Gardner/REX/Shutterstock: p.163
Tabatha Fireman / Getty Images: p. 175
Alice Ostapjuk / English Heritage: p.179, pp 180–181, p.183
© Julian Read: p.185, p.189
Jeff Spicer/Getty Images: p.186-187, p.188